IMAGES
of America

THE WOMEN OF SCRANTON
1880–1935

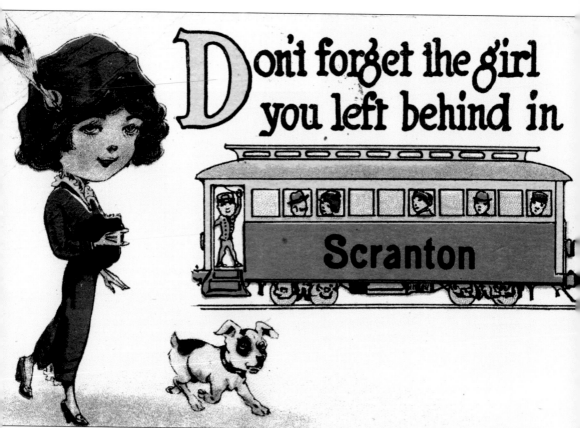

"DON'T FORGET THE GIRL YOU LEFT BEHIND IN SCRANTON." There is no written history of Scranton's early-20th-century women who marched for women's suffrage and temperance, combated the flu epidemic of 1918, labored for child welfare, established day nurseries and free kindergartens, and lived through the Great Depression. They were women of courage and industry when "anthracite was king" and are honored here. (Courtesy Jack Hiddlestone.)

On the cover: Please see page 53. (Courtesy Lackawanna Historical Society.)

IMAGES
of America

THE WOMEN OF SCRANTON
1880–1935

Josephine M. Dunn
and Cheryl A. Kashuba

ARCADIA
PUBLISHING

Published by Arcadia Publishing
Charleston, South Carolina

Printed in the United States of America

Library of Congress Catalog Card Number: 2005925675

For all general information contact Arcadia Publishing at:
Telephone 843-853-2070
Fax 843-853-0044
E-mail sales@arcadiapublishing.com
For customer service and orders:
Toll-Free 1-888-313-2665

Visit us on the Internet at www.arcadiapublishing.com

EFFIE JULIA WATRES AT PEN-Y-BRYN. Effie Julia Watres (née Hawley), active in women's initiatives in Scranton, would have agreed with attorney Priscilla Reichert, who stated, "In the year 2000, we should ask ourselves what was the outstanding feature of the first quarter of the 20th century. I think we should say it was not the world war nor the Russian Revolution, but the change in the status of women."

CONTENTS

ACKNOWLEDGMENTS

First, I thank Darlene Miller-Lanning, Ph.D., who asked why my exhibition Women and History in Northeastern Pennsylvania, 1880–1935 could not be a book. When Darlene's colleague Cheryl A. Kashuba offered expertise in layout and research, the opportunity to create this photo-documentary was irresistible. I am grateful to both, but I would like to thank each for her specific contributions. I am indebted to Darlene for having the camera, the eye, the time, and the patience to photograph many errant images. Thanks to Cheryl for the Marywood University captions and photographs, the images of the Home for the Friendless, and for authoring chapter 8. Sincere thanks to Jack Hiddlestone, whose collection of vintage postcards has filled many a blank page and who deserves so much more than thanks. Indefatigably, Arnine Weiss found sources for images that I longed to find. Sincere thanks to my colleague Lawrence Kennedy, Ph.D., for his support and assistance. How can I ever thank them?

Many thanks are due to a cadre of fine colleagues: Jason Amico (Pennsylvania Historical and Museum Commission), Nicole Barber (Girl Scouts, Scranton Pocono Council), Caryl Burtner (Virginia Museum of Fine Arts, Richmond), John Corkill (Scranton State School for the Deaf), Robert Dructor (Pennsylvania Historical and Museum Commission), Mindell Dubansky (Metropolitan Museum of Art), Louise Finetti (Century Club), Brian Fulton (the Times-Tribune), Cindy Garren (Girl Scouts, Scranton Pocono Council), Chester Kulesca (Pennsylvania Historical and Museum Commission), Edward J. Lynett Jr. (the Times-Tribune), Barbara Morley (Cornell University), Ann Marie O'Hara (Lackawanna Historical Society), Michael Pavese (Penn Foster Schools), Howell W. Perkins (Virginia Museum of Fine Arts, Richmond), Maureen Pesavento (Century Club), George S. Rose, Samuel K. Sandhaus (the Jewish Home of Eastern Pennsylvania), Gov. and Mrs. William W. Scranton, Mike Sherban (Pennsylvania Historical and Museum Commission), Richard Stanislaus (Pennsylvania Historical and Museum Commission), Rose Speranza (University of Alaska, Fairbanks), and Jennifer Warshney (Scranton chapter American Red Cross).

Lastly thanks are due to Tony, who moved gracefully and patiently through a home overtaken by research.

—Josephine M. Dunn

I would like to thank the following colleagues for their help: the Lackawanna Historical Society, its board of trustees, its staff and volunteers, and in particular Mary Ann Moran; Ann Marie O'Hara, Allan Sweeney, and Tiffany Goldy; Kristen Dieter and Sr. Delores M. Filicko, Immaculate Heart of Mary, both of Marywood University; Marilouise Ruane, Friendship House; Gary Roche; and Mary Beth Jaditz and Robbie Hoffman of the Robinson family.

—Cheryl A. Kashuba

INTRODUCTION

The Scranton woman who interests me came of age around 1880, when Scranton boasted 48,850 citizens. She stood on the edge of possibility while celebrating Lackawanna County's incorporation in 1878, vividly described here by Frederick L. Hitchcock, from *History of Scranton*, in 1914:

> In the evening, the victory was celebrated in a brilliant and never-to-be-forgotten manner. Lackawanna Avenue was illuminated from one end to the other. Bells were ringing, bonfires roared, the cannon thundered and thousands of people going from house to house singing and shouting their glad notes of triumph formed a pageant that would have done honor to any cause that ever claimed the prowess of knight or hero.

During the 1880s, she might have been the graduate of an established or new women's college, such as Mount Holyoke (1837), Vassar (1865), Wellesley (1875), or Smith (1875). State colleges had opened their doors to her (University of Michigan, 1870s), and higher education was attracting her to careers traditionally staffed by men (medicine and law). New tools had invaded the intimate spaces of her home. Washing machines, coal stoves, and electric lights changed the nature of her labor. Telephones (1876) and typewriters (mid-1870s) offered her tantalizing careers outside the home. She faced the prospect of becoming a wage earner like her father, brother, or husband.

By the time she was 50, Scranton's population had grown to 143,433. She had seen an immigrant population swell Scranton's labor force and witnessed the city grow from the well-regulated plan published by Joel Amsden in 1857. The post–Civil War growth in the nursing profession and the dramatic rise in number of women teaching were continuing to lure other Lackawanna women from their rural homes to the city. Between 1880 and 1935, this Scranton woman witnessed economic depressions, intermittent labor strikes by coal miners and silk-mill girls, increasing welfare legislation, an active Woman's Christian Temperance Union, rallies for women's suffrage, passage of the 18th and 19th constitutional amendments, the shock of World War I, the flu epidemic of 1918, the stock market crash of 1929, and the local sweatshop scandals of the early 1930s.

The years 1880 to 1930 may have seemed a time of endless crisis to this Lackawanna woman, but she met the challenge with energy and enterprise. The history of this era cannot be divorced from her ambitions and activities in all spheres of Scranton's civic, cultural, philanthropic, political, and humanitarian life. Who was she?

Alas, no history dedicated to the city's indefatigable early-20th-century women exists. Our study of extant histories of women in Scranton begins by regarding women through the eyes of

Scranton's male historians. The city's earliest biographers, Horace Hollister, author of *History of Lackawanna Valley* (1869); Frederick L. Hitchcock, author of *History of Scranton* (1914); and Thomas F. Murphy, author of *History of Scranton's Founding and Incorporation of the City of Scranton* (1941), record the names and activities of many women, occasionally including a full biography of singular ladies. Extracted from the considerably more detailed accounts of masculine enterprise that tend to marginalize them, the deeds of women are nevertheless formidable and worthy of closer study.

Scranton women began to look at their history in 1981, when the local branch of the Association of American University Women collaborated with 54 sister branches in Pennsylvania to produce *Our Hidden Heritage: Pennsylvania Women in History* (1984). Ten women were selected to represent Scranton, all epitomizing high levels of achievement and success as politicians, physicians, arts activists, and authors. *Our Hidden Heritage* birthed no successors, and the topic of women in local history has remained virtually undisturbed for 22 years. It is time, therefore, to rededicate our efforts in behalf of Scranton's leading ladies.

Documents on the history of local women exist in Scranton in the vertical files of the Albright Memorial Library; Lackawanna Historical Society files; archives of the Scranton chapter of the American Red Cross, the Century Club, and Marywood University; the museum at the Scranton State School for the Deaf; and in the pages of Scranton's newspapers (the *Scranton Times*, the *Scranton Republican*, and so on). Scranton city directories yield names, addresses, occupations, and advertisements for Scranton's early businesswomen, physicians, and lawyers. Two previous Arcadia Publishing books, *Scranton* and *Jews of Scranton* (both 2005), document some of the activities of women, and local historians Sally Teller Lottick, Sheldon Spear, and Kathleen Munley, Ph.D., have also studied a few of the region's remarkable women. Records may exist in the private collections of Scranton families; these we are still seeking.

Yet many more women await a biographer. Few remember Anna Calista Clarke, M.D., yet hers was a powerful voice for women in Scranton. As the first president of the local chapter of the League of Women Voters (1926–1955), she was active in suffrage and temperance causes and wrote as associate editor of the Women's Republican County Organization's newsletter, the *Searchlight*. One of the first women to graduate from the University of Michigan Medical School (1890), she opened her office to general practice in homeopathy at 320 Jefferson Avenue, Scranton, in 1893. Do you know of this 1952 Distinguished Daughter of Pennsylvania?

Who recalls the life and work of Carolyn Sickler (née Patterson), founder of the Parent-Teacher Association and assiduous director of the northeastern chapter of the Pennsylvania Federation of Woman's Clubs? What of Anne Huber, Mrs. Maxwell Chapman, Mrs. Ezra H. Ripple, Mrs. Benjamin Dimmick, Mrs. Ronald P. Gleason, Mrs. C. S. Weston, Clara Peck, Marion Margery Scranton, or Mrs. C. B. Penman? For many of us, these names have neither face nor deed, yet all left an indelible mark on the culture of Scranton.

Unless otherwise noted, all photographs belong to the Lackawanna Historical Society in Scranton. Other photographs are from the following: Ann Marie O'Hara (AMO); the Century Club (CC); Cornell University (CU); Darlene Miller-Lanning (DML); Frank M. Clemens (FMC); Gary Roche (GR); George S. Rose (GSR); the Girl Scouts, Scranton Pocono Council (GSSPC); Jack Hiddlestone (JH); the Jewish Home of Eastern Pennsylvania (JHEP); the Library of Congress (LOC); Marywood University (MU); the Pennsylvania Anthracite Heritage Museum (PAHM); the Penn Foster Schools (PFS); the Bureau of Archives and History, Pennsylvania Historical and Museum Commission (BAH); the Scranton State School for the Deaf (SSSD); the Times-Tribune (TT); the University of Alaska, Fairbanks (UAF); the Virginia Museum of Fine Arts, Richmond (VMFAR); and Gov. and Mrs. William W. Scranton (WWS). For full photograph citations, please see page 127.

—Josephine M. Dunn

One

SETTING THE STAGE

UNKNOWN SCRANTON WOMAN. The Scranton woman of 1880–1935 was many women. She was an immigrant, store owner, physician, lawyer, artist, teacher, homemaker, and nurse. She was English, Welsh, Irish, Russian, Ukrainian, Greek, Italian, Hungarian, and Polish. She lived in North Scranton, South Side, West Side, and on East Mountain. She prayed, worked, and played in sight of culm hills and breakers. Here follow select chapters from her history.

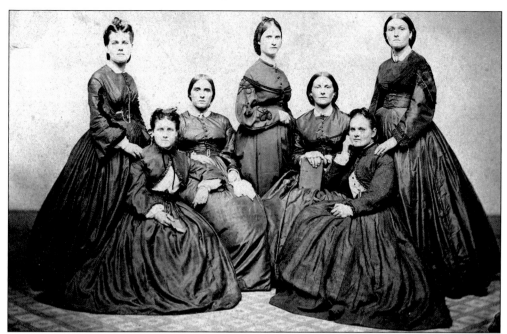

GARDNER FAMILY DAUGHTERS, GLENBURN. From left to right are Louisa (1831–1880), Dorcas (1833–1920), Rebecca (1838–1910), Lydia (1840–?), Nellie (1842–1917), Phebe (1846–1894), and Alice (1849–1910) Gardner. Some women born in mid-19th-century Scranton lived to see women receive the right to vote in 1920. Among her sisters, Dorcas lived just long enough to see dream become reality.

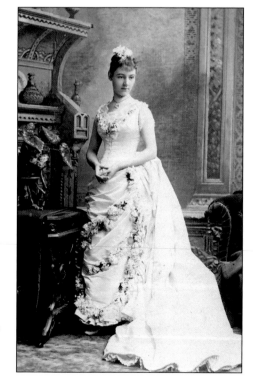

FULLER WEDDING, 1886. Most Scranton women envisioned marriage as their sole career and fully expected to be a genteel, self-effacing helpmate to their spouse. By the 1880s, however, more girls of the upper and middle classes were graduating from women's colleges and weighing the possibility of pursuing careers of their own.

OPHELIA AND ESTELLE HERSHFIELD WITH ESTHER MORRIS. Young girls born from 1880 to 1910 knew a very different world than had their mothers and grandmothers. They could, and did, become physicians, lawyers, nurses, office clerks, educators, and artists. By 1920, gainfully employed women in the United States numbered 8.2 million, and more than one-fourth of women employed outside agriculture were clerks, saleswomen, and typists. From left to right are Ophelia Hershfield, Estelle Hershfield, and Esther Morris.

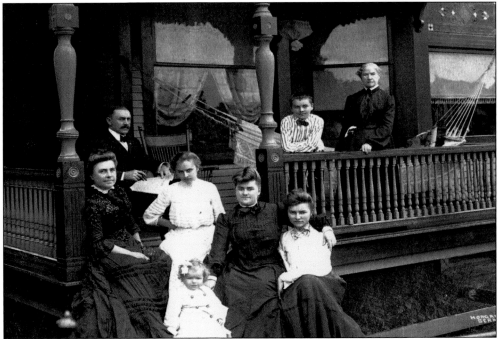

UNKNOWN SCRANTON FAMILY, C. 1900. Into the 20th century, Scranton women were challenged to become an integral part of urban commercial and professional life. Domestic and professional spaces, however, remained gendered, as this photograph subtly reveals. Father, heir, and family matriarch are placed high in the composition and effectively preside over wife and daughters, seated in the foreground.

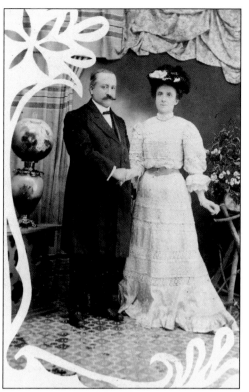

NICHOLAS AND CARMELLA SABATINE, c. 1910. Many women immigrants in the Lackawanna Valley worked alongside their husbands in family businesses established by parents or relatives. Marriage was eternal. Before the Civil War, divorce was unthinkable and, even by 1920, less than one percent of adults were divorced. Divorce was largely a luxury of the well-to-do and the sole route available to escape male misbehavior.

B. LONGINOTTI FRUIT, NUTS, AND CANDY, C. 1913. On the busy corner of commercial Lackawanna and Adams Avenues, B. Longinetti and his wife, Palmyra, operated a family condiments business assisted by clerk Rose Wolfe. They were part of a rising tide of immigration that swept America in the early 20th century. By 1907, the annual number of immigrants had risen from 427,833 in 1854 to 1,285,349.

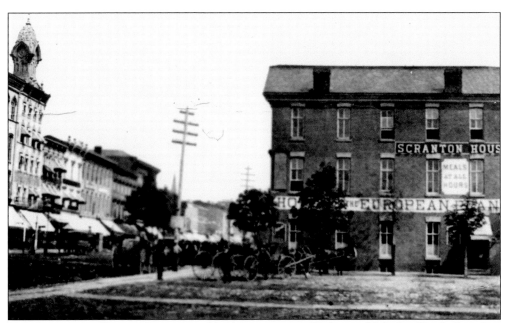

THE SCRANTON HOUSE. Spouses and business partners "Father and Mother Kessler," as they were known, owned the Scranton House in 1841 (sometimes called "Kessler's Hotel"). According to Frederick L. Hitchcock, Mrs. Kessler provided an "exceedingly home-like appetizing table of toothsome and well-cooked food, and an abundance of it . . . Who can forget the good things of Mother Kessler?"

JACOB D. CLARK, CIGAR MANUFACTURER. Clark Cigars was acquired by Herman W. Schmidt in 1904. Six years later, his widow took control of the store and ran it successfully until 1924, when production of the white ash cigar ceased. Widowhood brought Scranton women like Mrs. Schmidt the opportunity to move from the position of assistant to owner or manager.

WYOMING AVENUE. In 1914, Frederick L. Hitchcock observed an unusual fact: Lewis and Reilly (at 114–116 Wyoming Avenue) was managed by a woman. Mrs. Lewis-Evans's character pleased him because, although she asked "no favors from her masculine competitors on account of sex . . . [she was] so essentially feminine, gentle, and modest, that her success in the stern world of competitive business call[ed] for more than passing comment." (BAH.)

MINNA ROBINSON. Minna Robinson was born into the Schimpff family of Lautrecken, Bavaria, and immigrated to Scranton as a young girl. In Scranton, she married Philip Robinson, whose family had arrived in the United States in 1854. Philip acquired the family brewing business in 1868. When he died in 1879, Minna assumed management of the enterprise.

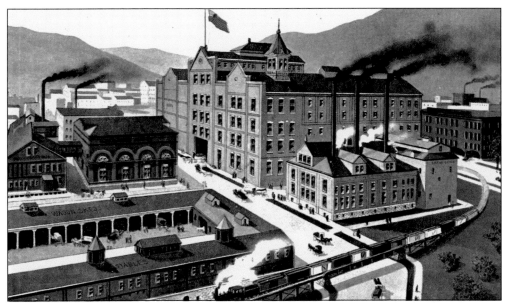

E. ROBINSON'S SONS BREWERY AND BOTTLING DEPARTMENT, POSTMARKED 1909. Eventually Robinson Brewing Company merged with the Pennsylvania Central Brewing Company, but Minna's son Edmund remained manager of the Minna Robinson Plant. His immigrant mother lived long enough to see her son achieve the American dream. Edmund became a prominent citizen in the financial and political life of early-20th-century Scranton. (JH.)

ROBINSON PARK, EAST MOUNTAIN. Minna Robinson donated 50 acres of land to Scranton for playground construction. In 1930, the *Scranton Times* acknowledged Robinson's philanthropy and that of other Scranton women (Mrs. Benjamin Throop, Mrs. Benjamin Dimmick, and Mrs. Henry Boies), stating, "A city which has men and women so thoughtful of the public welfare as to contribute largely of their means for the people's benefit and recreation is fortunate indeed." (DML.)

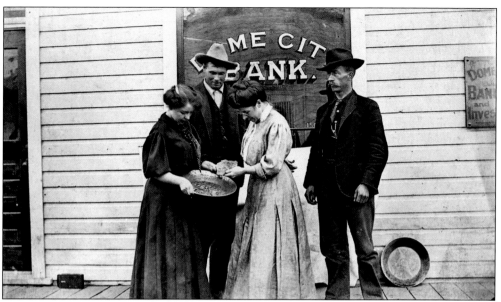

BELINDA MULROONEY CARBONNEAU. In this photograph, *Dome City Bank with Margaret Mulrooney, Miller Thosteseu, Belinda Mulrooney Carbonneau, Jack Tobin, Pioneer of Fairbanks,* stands the adventurous Archbald native Belinda Mulrooney (born in 1872). At age 18, she began an entrepreneurial career that spanned New York to San Francisco. She struck gold in Alaska, opened Fairbanks's Dome City Bank (1905), and is seen here standing outside the bank holding an 88-ounce gold nugget. (UAF.)

IMMIGRANTS. Most Lackawanna Valley immigrants found employment in the anthracite coal mines that peppered city and countryside. The wives often ran cottage industries, but the sheer number of women in Scranton constituted a ready-made working force that made the city attractive to textile industrialists. By 1910, silk mills employed more children than the anthracite breakers.

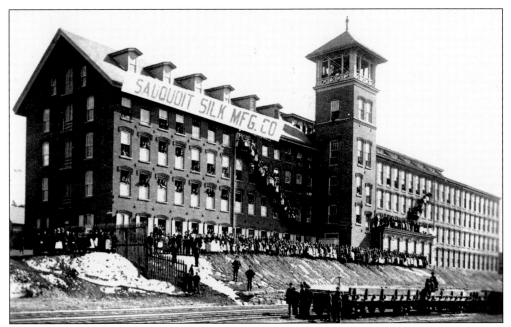

SAUQUOIT SILK MILL, C. 1910. The Sauquoit Silk Mill was invited by Scranton's board of trade to relocate to the city in 1873. Typical silk workers were 14- and 15-year-old girls who staffed the least-skilled and less-remunerated jobs (e.g., spinners, winders, and reelers). From 1899 to 1919, approximately three-fourths of children worked in the spinning departments. Pennsylvania child labor law (1909) prohibited night labor to girls over 14 years old and limited their daily working hours to 10.

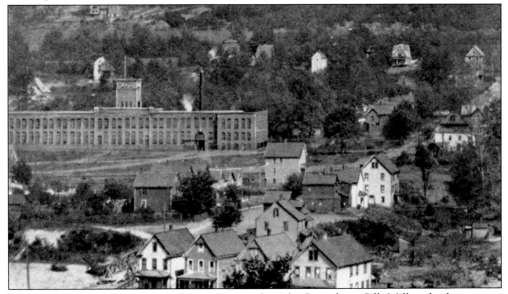

PETERSBURG SILK MILL, C. 1911. Ten years earlier, the Petersburg Silk Mill and others across the region were engaged in a five-month strike that brought Mary "Mother Jones" Harris to Scranton in support of working women on February 14, 1901. The *Scranton Times* had accurately predicted on February 1, 1901, that "the strikers are forming unions and it would not be surprising if all the mills in this region were tied up in the near future."

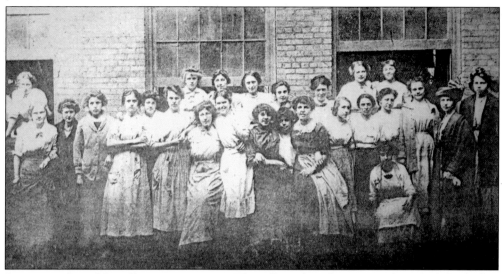

SAUQUOIT SILK MILL EMPLOYEES, 1910. The silk strike of 1901 was launched for higher wages, better conditions, and shorter working hours (from 10 to 8 hours). Unlike the nationally recognized strike of their coal-mining fathers, husbands, and brothers, the women's strike is less recognized locally but is no less important to the industrial history of early-20th-century Scranton. (JH.)

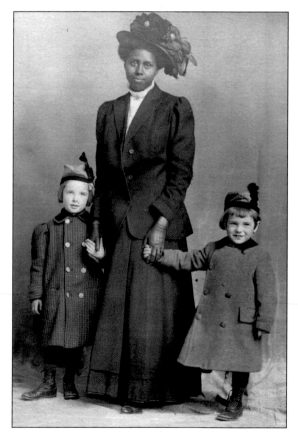

CLEVELAND WILEY, NURSEMAID, 1907. After emancipation from slavery, African American women focused on delivery of domestic and personal service, as does Cleveland Wiley. This, however, was not the only occupation of Scranton's enterprising African American women, as recent research is revealing.

Two

THE ARTIST WAS
A WOMAN

SOLDIERS AND SAILORS MONUMENT, COURTHOUSE SQUARE, 1899. A poem, "Send Them Home Tenderly," written by Harriet G. Watrous under the pseudonym of Stella of Lackawanna, was later set to music and sung around Union campfires. "Send them home tenderly, / Poor breathless clay, / Yet what brave hopefulness / Bore them away! / Hand to hand clingingly / Linked in sweet trust; / Tenderly—tenderly / Bear home their dust!" (DML.)

Panoramic View of Scranton, Pa., Looking West from Mulberry St. and Madison Ave.

PANORAMIC VIEW OF SCRANTON, 1916. The poem "Our City of Anthracite" reads, "In gallery, niche, and pillar; / In panel, and columned wall; / In transept, and nave, and casement / Our city surpasses all / The cities that men have builded / By the orient seas, afar; / Where spires in the sunlight glisten / And the olden grandeurs are. / Whichever the gate you enter— / From the

HARRIET GERTRUDE HOLLISTER WATRES. Sister of Horace Hollister, first historian of Lackawanna County, local poet Harriet Gertrude Hollister Watrous was born on January 27, 1821. After graduating from the Honesdale Female Seminary, she taught school. Marriage to Lewis Watrous in 1841 and the birth of six children did not impede her literary career under the nom de plume of Stella of Lackawanna.

day-glare broad and white / You will say 'tis a wondrous city— / Our city of anthracite; / And the people—the patient people— / Begrimed with the incense-smoke / From its many-altared temples, / Are a curious canny folk."

COBWEBS

BY

H. G. WATRES
(STELLA OF LACKAWANNA)

BOSTON
D. LOTHROP AND COMPANY
32 FRANKLIN STREET

COBWEBS, 1886. When Stella of Lackawanna died on March 2, 1886, the *Scranton Republican* observed, "For her there is no ordinary mourning, but widespread lamentation. None who knew her will cease to think of and revere her. Her place cannot be filled in the literary circles of Scranton."

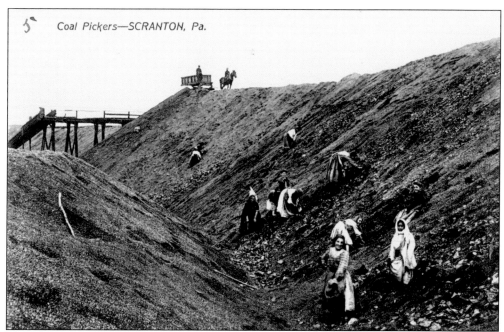

Coal Pickers—SCRANTON, Pa.

SLATE PICKERS, 1902. The poem "Tired" by Stella of Lackawanna opens, "To grope below in the darkness, / with Heaven so far away; / And search in vain for a sheltering arm / That in clasped you yesterday." (BAH.)

COAL PICKERS RETURNING WITH THEIR LOAD, c. 1909. The poem "Tired" concludes: "To grieve with a helpless grieving; / And wearily watch and wait / For the treasures your life has somewhere lost; / This—this your woman's fate." (PAHM.)

MINERS FAMILY, 1902. The poem "Faces on the Street" by Stella Lackawanna reads, "There are faces—how they haunt us / Day by day! — / Though we struggle to forget them / Best we may: / How they flash along the dusky / Path of thought! / How they trouble us, by coming / All unsought."

MINERS HOME AND FAMILY, 1902. "Faces on the Street" concludes, "More of grieving than of gladness; / More, alas, / Of mute yearning in the faces, / As they pass: / Is it poverty, or struggle, / Or defeat, / All this hunger in the faces / On the street?" (PAHM.)

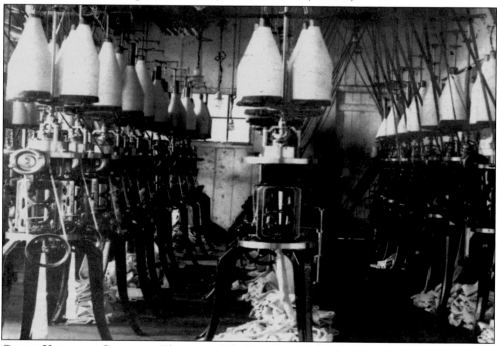

GREAT KNITTING COMPANY. The poem "My Loom" by Stella of Lackawanna reads, "I watch the shuttle the weavers throw— / The weavers bent with a life-long toil / For care builds many a loom, you know, / Where the strong and the weak alike must moil." (JH.)

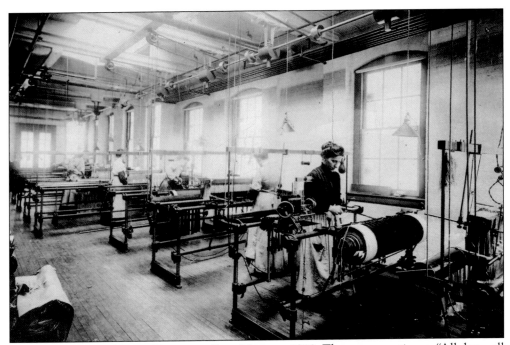

INTERIOR VIEW OF BLACK DIAMOND SILK MILL, C. 1910. The poem continues, "All day—all day, and far in the night; / Why not go chat with the birds instead? / But the master's eye is on me now, / So I weave in my loom another thread."

PORTRAIT OF ALICE CORDELIA MORSE (1862–1961). This portrait, published in A Woman of the Century (1893), depicts Alice Cordelia Morse at the outset of her career as designer of handcrafted book covers. Authors Frances E. Willard and Mary A. Livermore describe Alice as a "very clear, original thinker, with an earnestness relieved by a piquant sense of humor, a fine critical estimate of literary style and a directness of purpose and energy." (WOC.)

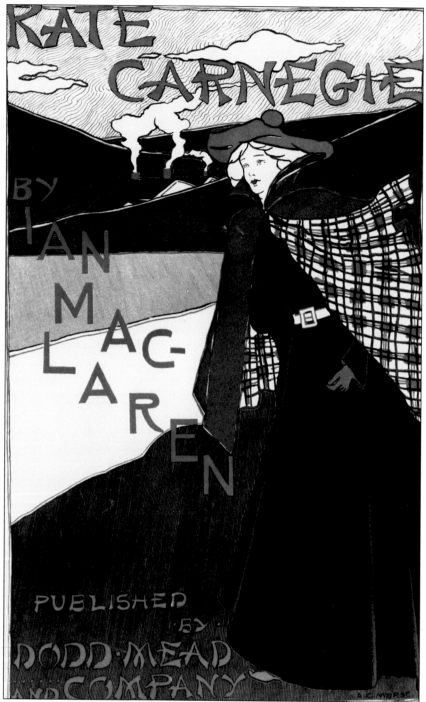

ALICE C. MORSE, BOOKCOVER FOR *KATE CARNEGIE*, C. 1896. Alice C. Morse studied at the Woman's Art School, Cooper Union, New York City, and with John La Farge and Louis C. Tiffany and Company, leading American stained-glass designers. In 1898, she moved from New York City to Scranton to teach art. Here, from 1917 through retirement in 1924, she served as head of the drawing department at Central High School. (VMFAR.)

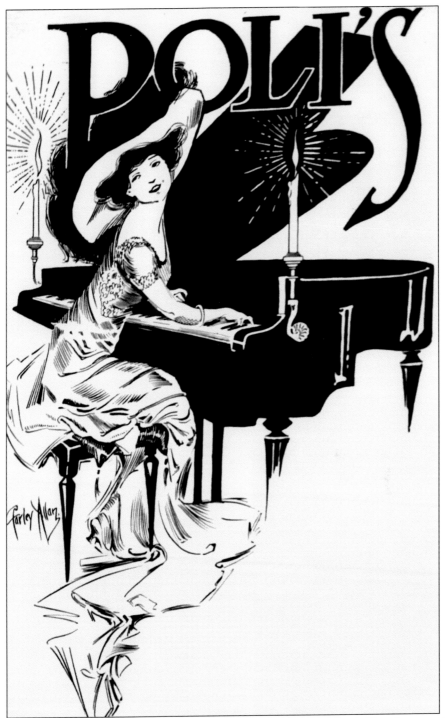

SARAH FARLEY-ALLEN. Artist-designer Sarah Farley-Allen was born in 1879 in Jermyn. There she owned a studio near the Wanamaker Store and earned her living by designing bold covers for local journals and exhibitions. She was well known and admired for her creative black-and-white newspaper advertisements for Scranton's Poli Theatre.

POLI THEATRE. New Haven, Connecticut, theater operator S. Z. Poli opened a vaudeville theater in Scranton in 1907. During the fourth season (1911), a new vaudeville actor premiered at the theater: Will Rogers. Later celebrities who "played the Poli" include Fanny Brice (1914), Harry Houdini (1915), the Mack Sennett Bathing Beauties (1919), and Jack Benny (1920), not to mention Jasper, the Trained Dog (1916).

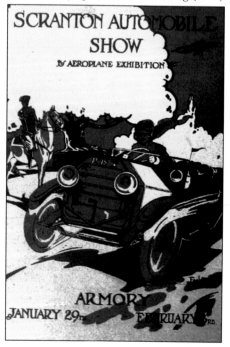

SCRANTON AUTOMOBILE SHOW AND AEROPLANE EXHIBITION. For the Scranton Automobile Show and Aeroplane Exhibition, held at the armory in Scranton (January 29–February 3 [year not cited]), Sarah Farley-Allen depicted a modern woman whose hands confidently grip the wheel of a modern roadster. The car is speeding and the driver leans forward with a smile, her neck scarf wind-borne. Vainly, a mounted policeman cautions her from the roadside.

GOLD MEDAL HAARLEM OIL. In 1925, Poli sold his theater to the Comerford Theater Chain for $30,000. Hence, the finest vaudeville theater in Scranton relinquished its long-term patronage of Sarah Farley-Allen. The artist continued, however, to provide well-designed newspaper advertisements for Scranton audiences through her large local clientele, including the Holland Medicine Company.

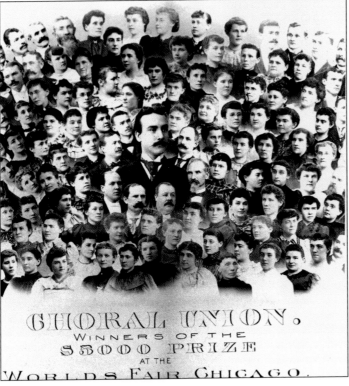

SCRANTON CHORAL UNION, CHICAGO WORLD'S FAIR. At the 1893 Columbian Centennial, Scranton's 300-member choral union, conducted by John. T. Watkins, took first prize ($5,000). At the fair, Scranton's singing women had the opportunity to visit the women's pavilion and to see Emma Garrett's display on Scranton's Oral School for Deaf Mutes. When the group returned to Scranton, 30,000 jubilant fans greeted its arrival.

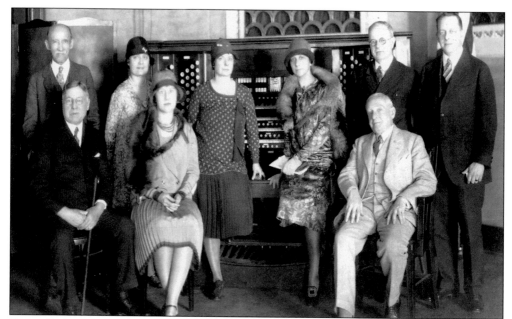

FIRST COMMUNITY CONCERT BOARD. The 1928 president of the Community Concert Board was Ellen Fulton (second row, third from the left). At the Century Club, Fulton presided over the club's musical events and developed music programs and music-education enterprises for the Pennsylvania State Federation of Woman's Clubs as well. A poetess, she wrote regularly for the *Century Club Magazine.*

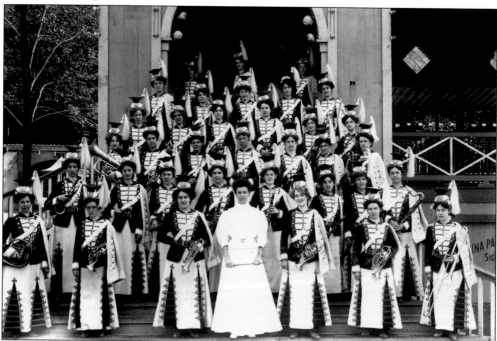

NAVASSAR LADIES BAND, APRIL 1, 1907. This photograph was made by Luna Park Studio in Scranton. There were many forms of entertainment at Luna Park, but an all-woman orchestra was decidedly exotic—and marketed as such. (LOC.)

Three

WOMEN AND THE LAW

HOTEL JERMYN, 1916. Scranton celebrated its 50th anniversary in 1916, and the formation of the Lackawanna County League of Women Voters by Dr. Anna C. Clarke was 10 years away. In 1902, Clara Peck had passed the Lackawanna bar exam to become Scranton's first woman lawyer. "Will considerations of gallantry induce [male lawyers] to lose their cases to her?" queried the *Scranton Times*.

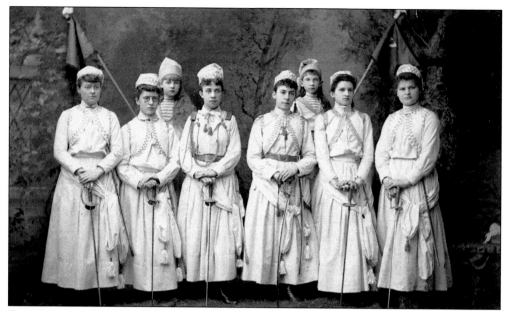

FUND-RAISING FOR THE "NEW ARMY." During the late 19th century, women learned skills of organization through participation in organizations affiliated with religious institutions and with the women's auxiliaries of exclusive male clubs. They brought new skills to advancing women's suffrage. On the photograph's reverse are written: Colonel Cora M. Decker (wearing Col. Ezra Ripple's belt, sword, and epaulettes), Alice Warkiser, Major Miller, Gaylord Sargent, Anna Chase, Jessie Connell, Marie Bloom, Hattie Stanton and Ada Miller.

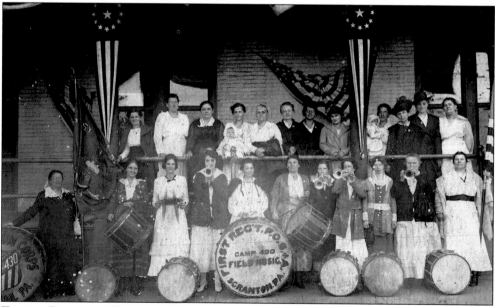

THE 1ST REGIMENT, PATRIOTIC ORDER OF SONS OF AMERICA. Scranton's first Patriotic Order of Sons of America camp, No. 178, was organized in December 1892, and three years later a ladies' auxiliary (camp No. 430) was established in South Scranton. The auxiliary placed American flags in many public schools and erected the monument to George Washington on Courthouse Square.

Scott Valley Temperance Union.

"WITH MALICE TOWARD NONE AND CHARITY FOR ALL."

I, the undersigned, do PLEDGE my WORD and HONOR

GOD HELPING ME,

to abstain from ALL INTOXICATING LIQUORS as a beverage, and that I will. by all honorable means. encourage others to abstain.

Francis Murphy.

1878.

TEMPERANCE PLEDGE, 1878. In 1901, members of Scranton's Woman's Christian Temperance Union (WCTU) responded to Carrie Nation's saloon smashing in Kansas: "We regret the necessity of Mrs. Nation's action, because of the violation of the Kansas temperance law, and we are led to sympathize therefore with her object and motive, and are awakened to the thought of the small redress which woman has against the liquor traffic."

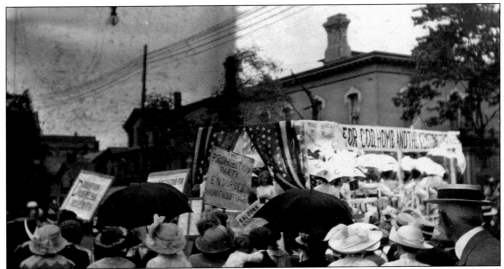

PROHIBITION AND SUFFRAGE PARADE. As in many American cities, the Scranton WCTU supported women's suffrage. (Note the Prohibition Party Endorses Women's Suffrage sign.) In 1915, the *Times-Leader* reported, "The 'Votes for Women' question is of vital importance—it marks a new order of things, a radical departure from fixed conditions and is worthy of the most careful consideration and deep thought." (FMC and JH.)

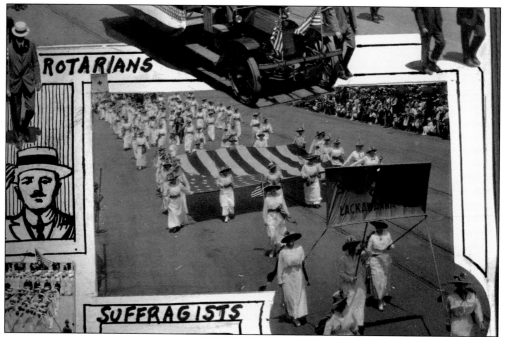

PREPAREDNESS PARADE, SCRANTON, 1916. In 1916, the City of Scranton sponsored a preparedness parade in which a number of women's organizations participated. Lackawanna County suffragists joined women of the Century Club, International Correspondence School (ICS) staff, and women employees of Clarke Brothers in a patriotic parade designed to demonstrate community readiness to serve the country. (CC.)

MRS. MAXWELL CHAPMAN, 1914. Mrs. Maxwell Chapman was the founder and president of the Lackawanna County Equal Suffrage League and vice president of the state organization when the State Woman's Suffrage Association convened in Scranton in November 1914. From a bare handful of women in 1912, the league had grown to 4,690 members two years later. As division leader, Chapman directed suffrage activities in 10 northeastern Pennsylvania counties and ran Scranton's suffragist restaurant.

"Suffragists Looked Good to Walsh," 1914. Jim Walsh, cartoonist for the *Scranton Times*, represents Mrs. Maxwell Chapman as "the Major General of the Suffragists." Also depicted is public relations director Kathryn Reed, "who sewed the stars on the 'suff' flag." She is depicted saying, "Not Red," referring to the red rose, symbol of the anti-suffragists. (The suffragist flower was the yellow chrysanthemum.) (TT.)

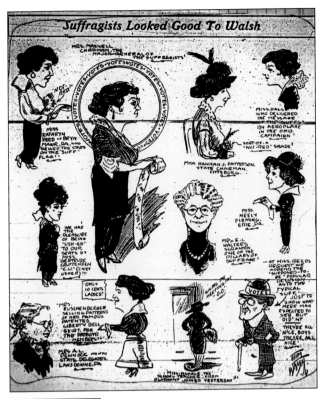

Ella Murray. The *Scranton Times* numbered Ella Murray among local suffrage workers at the annual convention of the Pennsylvania Woman's Suffrage Association in 1914. At this meeting, known as the "campaign convention," the state plan was announced "to have one suffragist watch every ten male voters during an election day." (Ella's sister Agnes O'Loughlin successfully lobbied for a women's suffrage plank during W. R. Hearst's New York mayoral campaign.) (AMO.)

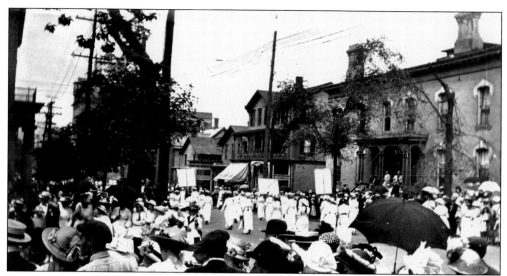

SUFFRAGE AND PROHIBITION PARADE, SCRANTON. This parade in Scranton was a familiar sight to attendees of the annual conferences of the State Federation of Pennsylvania Women before 1920. Marching toward the intersection of Jefferson Avenue and Linden Street, the gallant women here are passing the entrance portico of the YWCA (left), where many conventions' activities took place. (FMC and JH.)

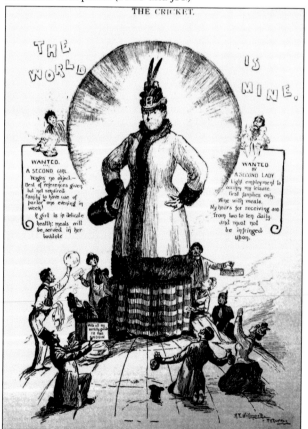

THE CRICKET, NOVEMBER 9, 1889. This cartoon, "The World is Mine," mocks fear of the "independent woman." The bedraggled man behind the left text panel timidly advertises for "A Second Girl, wages no object. Best of references given but not required. Family to have use of parlor one evening in week. If girl is in delicate health, meals will be served in her boudoir."

SUFFRAGE CONVENTION, HOTEL CASEY, SCRANTON, NOVEMBER 14. On November 18, 1914, the *Scranton Times* predicted that the Pennsylvania Woman's Suffrage Association convention would be "one of the most profitable educational events ever achieved by the Pennsylvania organization . . . Exhibitions explaining pure and impure food and drugs, home management, voting methods and openings for women in civic affairs will be among the features." (BAH.)

DOME BALCONY, BEAUTIFUL HOTEL CASEY, SCRANTON, PA.

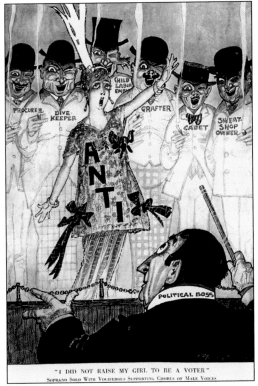

"I DID NOT RAISE MY GIRL TO BE A VOTER"
SOPRANO SOLO WITH VOCIFEROUS SUPPORTING CHORUS OF MALE VOICES

"I DID NOT RAISE MY GIRL TO BE A VOTER," 1915. In October 1915, a suffrage debate was held in Scranton between Mrs. O. D. Oliphant (New Jersey), representing the Anti-Suffrage Party, and Gertrude Fuller (Pittsburgh), of the Suffrage Party. The packed audience in Athletic Hall, South Scranton, listened as Oliphant denigrated suffrage as socialism and erroneously claimed that only 10 percent of Pennsylvania women favored suffrage. (LOC.)

MARION MARGERY WARREN AND MOTHER, ELLEN H. WARREN. When Marion Margery Warren was born, women could not vote. By the time she was 36, women had the franchise. Who could have imagined, here, that they were looking at the first woman in Lackawanna County to drive a car, as well as founder of the first partisan women's political organization in the United States? (WWS.)

FOUR GENERATIONS, 1908. From left to right are Marion Margery Griffin Warren, Marion Margery Warren Scranton, Marion Margery Scranton (born in 1908), and Ellen H. Warren. Governor Scranton reported: "[Margery] participated in rallyings and picketings . . . When they got [the 19th amendment], she became active in state-wide politics . . . Towards the end [of suffrage], she was putting as much as 30-40,000 miles a year going all over the state speaking and working . . . for woman's suffrage." (WWS.)

MARION MARGERY WARREN. "She was apt to be quite far ahead of her time in what a woman should do and what a girl should be," according to her son. At the age of 16, in 1900, her father allowed her, at her request, to take a train alone to Harrisburg to picket for woman's suffrage. (WWS.)

MARION MARGERY WARREN SCRANTON. Margery "spent a lot of time in Harrisburg lobbying the Legislature for the Mother's Assistance Fund . . . She was the only reason [it] . . . got through the Legislature back in the early '30's, or late 20s-early 30s, when a lot of mothers were in great, dire need . . . We wouldn't have had it unless she had pushed it through," stated governor Scranton. (WWS.)

MARION MARGERY WARREN AND FAMILY, C. 1917–1918. Margery, wife of Worthington Scranton, had three daughters besides Pennsylvania's Gov. William W. Scranton: from left to right are Katherine (1910–2002), Sara (1913–1997), and her namesake, Marion Margery (1908–1992). (WWS.)

MARION MARGERY SCRANTON AND WILLIAM W. SCRANTON, 1908. According to governor Scranton, many women "looked rather askance at [mother] because [politics] wasn't something in her day that women did . . . [because] it was not proper and socially correct. But most women . . . were very happy . . . [because] not only [was she] working very hard at it, but . . . [she was] showing a good deal of leadership." (WWS.)

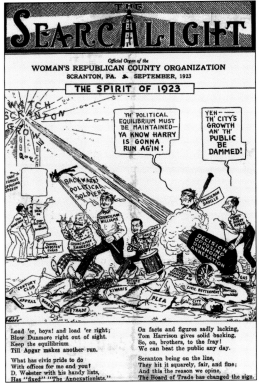

"THE SPIRIT OF 1923." Scranton's Republican women published a small magazine, *The Searchlight*. In 1923, a special cover cartoon (volume 1, No. 7) satirized Scranton's proposed annexation of Dunmore and depicted the "progressive" parties of Scranton trampled and vanquished beneath the marching feet of city councilmen. Identified among the fallen is, notably, one woman's organization, the Century Club, and a cause to which the club was dedicated, civic betterment.

VIOLA GLASER

Republican Candidate For

City Council

YOUR SUPPORT SOLICITED

Registration Dates—September 6th,
September 11th and September 15th

That the women may be represented in the City Government, I am seeking the nomination for City Council on the Republican Ticket at the Primaries on September 18.

If elected I pledge myself to carry out the following platform:

Better assessment, thereby reducing and equalizing taxation.
Market Houses for farm produce in different parts of city.
Better Sewage.
Better Garbage Collection.
Extension of Street Railway Service.
Abolishing Grade Crossings.

"A Woman for Council." Enjoining its readership to put a woman on city council, *The Searchlight* stated in 1923, "The newspapers have studiously refrained from mentioning [Mrs. Glazer] . . . so we will make a special announcement that the women of the city may know how difficult it is for any woman running for office to get 'a square deal' when it comes to entering the political field."

Official Organ of the
WOMAN'S REPUBLICAN COUNTY ORGANIZATION
SCRANTON, PA. ♣ JULY, 1923

The Searchlight, 1923. Mrs. Maxwell Chapman and Dr. Anna C. Clarke, editors of the Woman's Republican County Organization newsletter, opined, "The majority of women doing journalistic work are doing it in . . . society work, women's clubs, book reviews, fashions and special articles . . . In a small town women have a better opportunity for advancing than they do in a city . . . A girl who shows ability can often work up in the profession." Mrs. C. B. Penman "worked up," but Elizabeth R. Lynett was born to the career of coeditor.

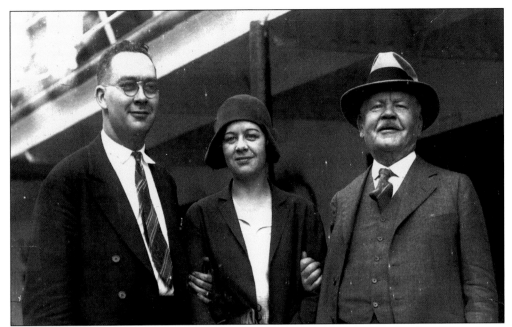

ELIZABETH RUDDY LYNETT. Elizabeth R. Lynett stands with her coeditor brother, Edward, and father, E. J. Lynett Sr., editor of the *Scranton Times*. In May 1933, Elizabeth went undercover to expose low wages and poor working conditions of young women and children employed in Scranton's garment industry. Her exposés of May 21–29 led to the appointment of a federal board to investigate local sweatshop conditions. (TT.)

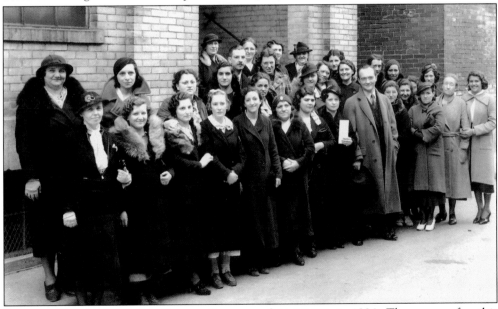

STRIKERS POSE DURING THE SECOND STRIKE IN SCRANTON, C. 1930. Three years after this strike, Elizabeth R. Lynett planned "to get a job as an unskilled worker [like these], to mingle with the girls and women as a fellow employee . . . to get first-hand information on general conditions obtainable in no other way. [And] to discover what these women were able to earn after a week's hard work." (CU.)

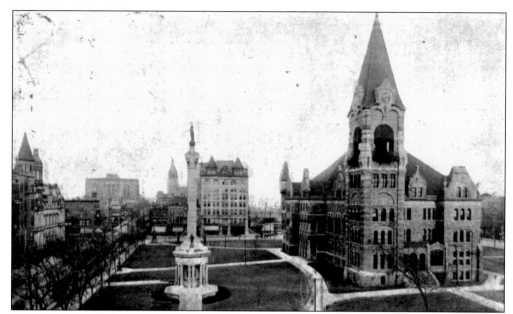

LACKAWANNA COUNTY COURTHOUSE. Besides Clara Peck, other women were studying law in Scranton as the *Scranton Times* reported in 1902. They were Abbie Watrous, "who became expert in the drawing of indictments"; Anna Robert W. Archbald, rumored to be assisting her father, Judge Archbald, in the writing of a textbook on law; and Kate Winton, who, as the *Scranton Times* quaintly stated, gave up the court to "courting" by Gilbert G. Murray.

LAWYERS, 1905. When Clara Peck was admitted as a "new limb of the law" to the Lackawanna bar, the *Scranton Times* (1902) pondered her effect on the courtroom: "It will be interesting to watch the effect upon the male members of the legal fraternity, who have heretofore enjoyed a monopoly of the privileges of sitting inside the bar enclosure and the duty of laughing at jokes perpetrated by the court."

Four

EDUCATING WOMEN

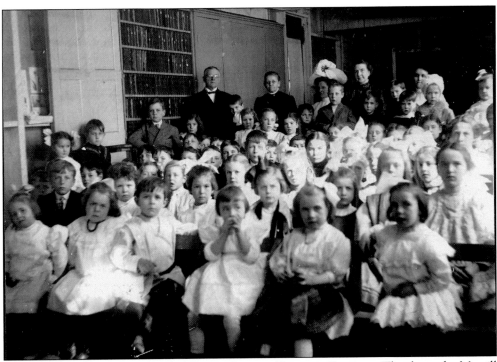

SUNDAY SCHOOL GROUP, PENNSYLVANIA AVENUE BAPTIST CHURCH. Thanks to the Morrill Act of 1862, requiring state universities to make college education accessible to women, these young girls could imagine, if not accomplish, a college education at a non-women's college. By 1890, American females outnumbered males as high school graduates, and by 1910, 30.4 percent of female high school graduates were enrolled in colleges, universities, and technical schools.

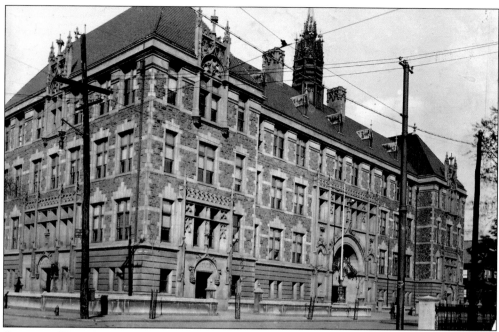

CENTRAL HIGH SCHOOL. Before Central High School (CHS) was built, an earlier high school had occupied the site since 1877. Describing the latter school, Frederick L. Hitchcock wrote, "It is not recorded that any of the girls of this city in these primitive times aspired to college education . . . [as do girls today] . . . and who thus become capable of filling the highest positions in the profession of teaching."

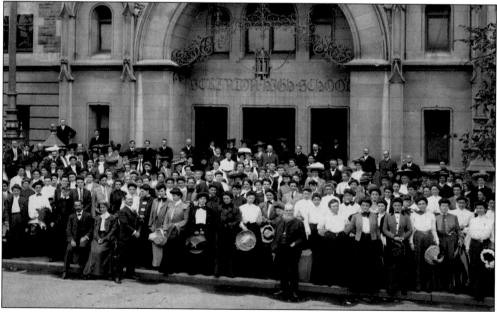

GROUP OF CENTRAL STUDENTS. CHS was dedicated in 1896 and offered education in three areas: classical (college preparation), scientific (engineering), and general (normal schools for teachers). Girls enrolled in CHS attended one session daily, 8:30 a.m. to 1:00 p.m., and were expected to apply themselves to at least three hours of study at home.

TECHNICAL HIGH SCHOOL. Before 1905, Scranton boasted only one high school, but the creation of Technical High School (THS) provided additional career opportunities for Scranton girls. Commercial courses previously taught at CHS were transferred to THS, and a four-year curriculum in commercial courses supplied training in bookkeeping, stenography, and typewriting. From 1900 through 1920, one out of two American women were entering the clerical workforce.

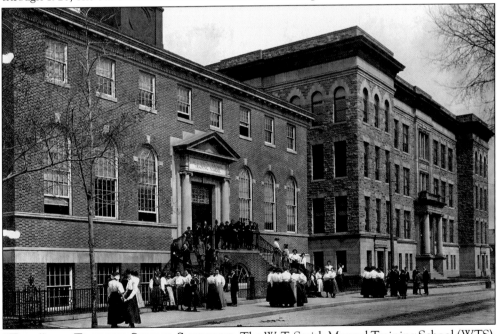

"TECH" AND TRAINING SCHOOL STUDENTS. The W. T. Smith Manual Training School (WTS), foreground, was given to the city by Mrs. W. T. Smith as a memorial to her husband and to fulfill his wishes for the education of Scranton's youth. It became part of THS, at Adams Avenue and Gibson Street. The two school buildings were connected by an enclosed corridor.

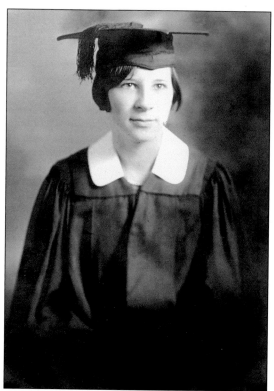

GRADUATE. In 1914, CHS graduated 44 boys and 18 girls in the classical curriculum, 40 boys and 4 girls in the scientific curriculum, and 2 boys and 3 girls in the general curriculum. A total of 111 graduates attended 28 different colleges, among them women's colleges such as Wellesley, Vassar, Smith, and Hahnemann Medical Hospital for Women in Philadelphia.

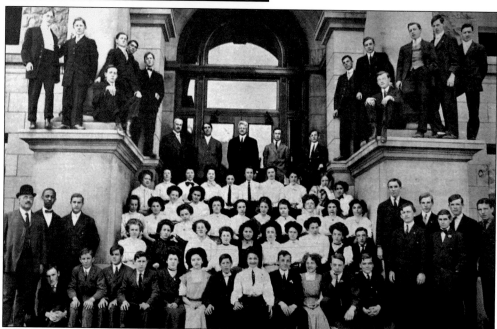

THS GRADUATES, 1909. The 1909 class at THS was the first to complete a four-year high school course. Students entering THS had to pass an examination that tested on English, grammar, arithmetic, United States history, geography, and spelling. In 1914, education was still free to city residents, but nonresidents paid $75 annually.

FOURTH THS COMMENCEMENT, 1910. The 1910 THS graduation ceremony honored salutatorian Sarah Margaret Finnerty and valedictorian Bella Vilensky. Charles Zeublin addressed students on education and industry. Of the 65 graduates in commercial courses, 37 were women, while 17 women graduated in manual training. The decrease in number of manual graduates generally reflected the growing trend among women to seek office over mill jobs.

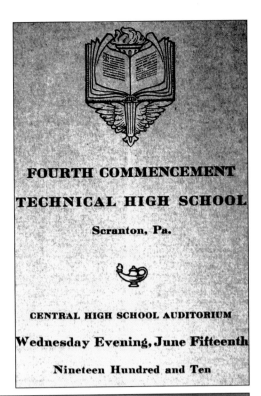

FOURTH COMMENCEMENT

TECHNICAL HIGH SCHOOL

Scranton, Pa.

CENTRAL HIGH SCHOOL AUDITORIUM

Wednesday Evening, June Fifteenth

Nineteen Hundred and Ten

THS CLASS OF 1920. The ratio of women to men is worth noting in this photograph. THS women graduating in manual training studied how to make clothing and trim hats, how to cook plain and fancy dishes, and how to launder and remove stains. Frederick L. Hitchcock explained, "The whole idea of the courses is to teach the girls to become good home-makers."

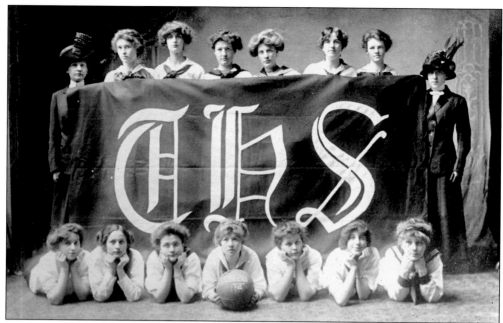

THS Basketball Team, 1910. An advocate of physical education, Mrs. J. E. Sickler, in 1927, wrote, "[Once, we thought if a girl] . . . were strong enough to step over a curbstone, [she should] . . . disguise the ugly fact and cling daintily . . . to the sturdy right arm of [an] escort . . . [And] if she could run fast enough to catch up to what she wanted, nobody had ever seen her do it." (PSA.)

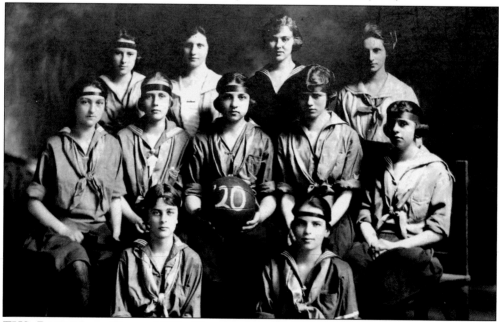

THS Basketball Team, 1920. The *Scranton Times* reiterated Sickler's point in 1930: "Grandmother wore herself out carrying around a number of petticoats. Mother pulled her waist into an hourglass and encased it in steel . . . Recreation was for the men of the family. Adult women stayed home to sew, preserve, knit, hemstitch, patch quilts, bake, cook, scrub and do the work of a dozen machines."

EDITORIAL BOARD, "IMPRESSIONS." Males comprise the larger number of CHS editors, but women had joined the ranks by 1898–1899. In 1901, the *Scranton Times* reported, "there has not been a time in ten years when every daily paper in this city has not had at least one graduate from the High School on its editorial staff."

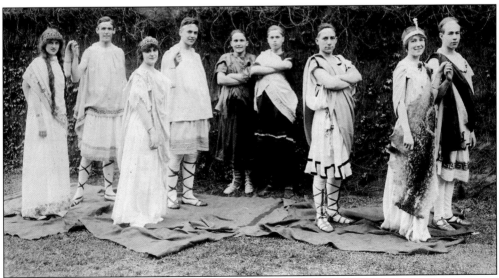

A MIDSUMMER NIGHT'S DREAM, MAY 1914. At both CHS and THS, students were required to study English, write original compositions, and learn appreciation of good literature in order to "have work tend to utility." Communication and language skills were highly prized in women as well as men, as was the ability to write well and clearly. In drama classes, elocution was rigorously taught.

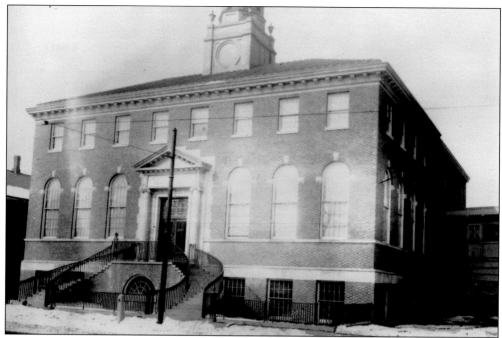

MAIN BUILDING, W. T. SMITH MANUAL TRAINING SCHOOL. Established in 1905 by physician W. T. Smith's widow, WTS educated men and women. Frederick L. Hitchcock described Mrs. Smith as a woman of "utmost culture and refinement, active and prominent in every worthy cause, giving freely of her time and substance to those less fortunate in the world's goods." She also funded a children's wing at the State Hospital.

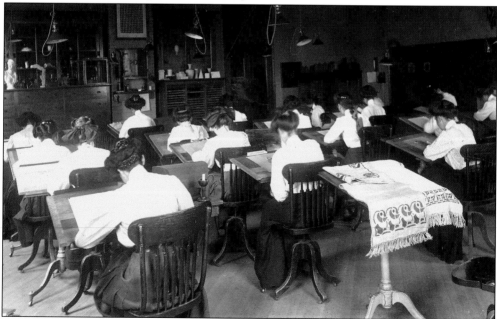

WTS DESIGN CLASS. Manual training courses for girls included the applied arts, such as weaving, rug making, embroidery, Irish crochet, and leather tooling. Courses in design were foundation courses for the applied arts.

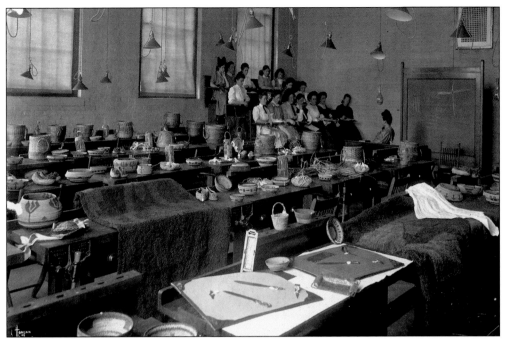

WTS BASKETRY CLASS. Besides basketry, manual training also included hat trimming, laundry and stain removal, and cooking for invalids and children. Martha Taft Wentworth, author of "The Household Column" in the *Scranton Republican* (1901) had longed for the day "when economy of a practical ordering may be a part of the public school curriculum" and exhorted, "Let it take rank with reading, spelling, writing, arithmetic and hygiene."

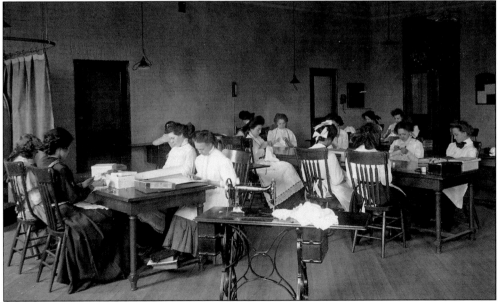

WTS SEWING CLASS. The sewing classes were part of the domestic arts curriculum that comprised plain and advanced sewing, shirtwaist making, dressmaking, and millinery. These skills served household needs, supported part-time work for women in their own homes, and provided women with skills for hire as seamstress or milliner.

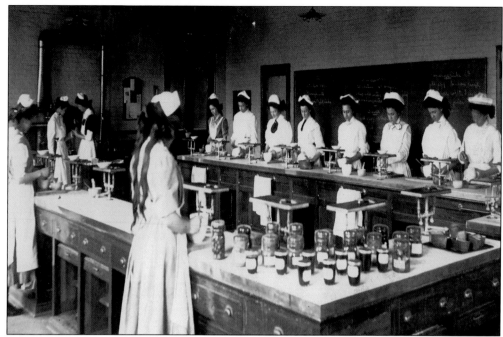

WTS Canning and Jelly-Making Class. Domestic science comprised courses in food preservation (canning), and girls studied bacteria and food-induced illness. First-year courses focused on food constituents: water, minerals, carbohydrates, fats, and proteins. Students also learned nutrition and became expert in making tea, coffee, chocolate, and scalloped dishes and in preparing fruits, vegetables, cereals, eggs, and meat.

Emma Garrett. Emma Garrett was the first principal of Scranton's Oral School for Deaf Mutes from 1889 through 1891. Formerly a student of Alexander Grahm Bell at the Bostono School of Vocal Physiology, she graduated first in her class. She believed that a 10-year course of teaching for deaf children was not sufficient and stressed the importance of "trained articulation teachers" talking to children and encouraging them to express themselves. (SSSD.)

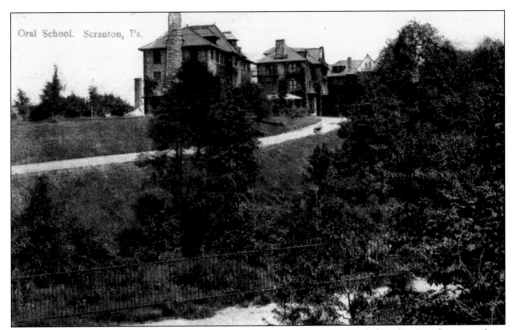

ORAL SCHOOL, C. 1889. The school (now Scranton State School for the Deaf) opened on September 10, 1883, to 10 students. Garrett arrived in 1884 and, when the school incorporated in 1889, became its first principal. In 1891, she left Scranton for Philadelphia to found the Home for Training in Speech for Deaf Children Before They Are of School Age. (BAH.)

ARCHITECTURAL PLANS, COLUMBIAN EXPOSITION DISPLAY, C. 1893. Emma Garrett described her career as follows: "In 1884, at the request of Mr. Henry Belin Jr., Judge Hand, and other philanthropic men of Scranton . . . [I went] to establish the Pennsylvania Oral School . . . [and remained principal through 1891, when] . . . the building provided by the State being filled to overflowing, a second building was made necessary." (SSSD.)

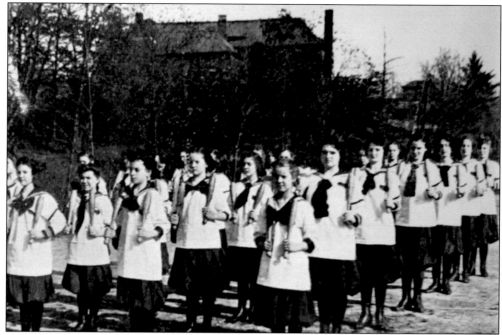

GIRLS' GYM CLASS, ORAL SCHOOL, 1906. The physical education, health, and well-being of girls were advocated in early-20th-century schools. At the Oral School for Deaf Mutes's first commencement in 1901, the *Scranton Times* reported that students performed "a beautiful Delsarte drill, showing emphatically that the physical development of the children is not neglected." (SSSD.)

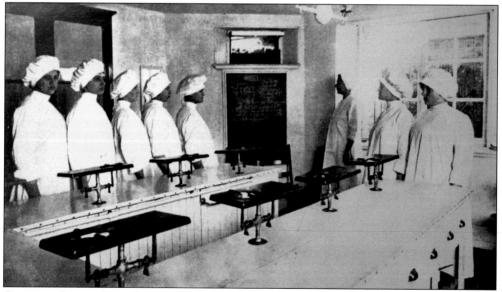

COOKING CLASS, ORAL SCHOOL, COLUMBIAN EXPOSITION DISPLAY, C. 1893. In 1892–1893, Emma Garrett argued "that [children] be allowed the opportunity [to work] . . . among people with whom they will . . . do business." She exhorted, "Let us in every way try to lead them forward; they will do their share . . . if we only give them a genuinely fair chance." She built her curriculum on this premise. (SSSD.)

ELEANOR JONES. In 1955, after teaching three generations of children, the retired Eleanor Jones (instructor from 1904 through 1954) received word from her former students: "The girls went to cooking class last Thursday after school. We made three different kinds of candy. They were Marshmallow Crispy Treats, Chocolate Truffles, and Peanut Butter Fudge. We ate them. We liked them because they were very good." (SSSD.)

STUDENTS, ORAL SCHOOL, C. 1915–1916. Garrett reported that the school received a medal at the 1890 Paris Exposition and that she was invited to promote her educational program at the children's building of the 1893 Chicago's World Fair. In "An Interesting Pupil" (*American Annals of the Deaf*, 1884), she wrote that "ideal education for a deaf child was that he should never see another deaf child." (SSSD.)

FIRST GRADUATION CLASS, 1901. During the first commencement, two women received their diploma from Col. Lewis A. Watres: Jennie Brookhart (of Williamsport) and Eleanor Markham (of Mercer). The *Scranton Times* noted, "They have . . . shortened the course by two years . . . [having] been here eight years instead . . . of ten. This mark of ambition entitled them to return next year . . . [to] take a post-graduate course . . . [while serving as] teachers." (SSSD.)

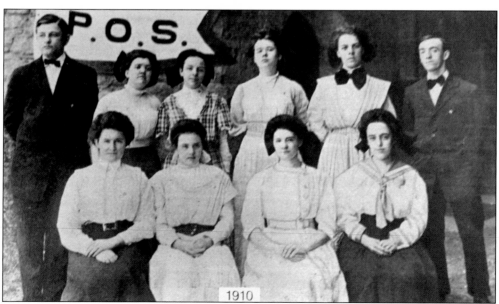

GRADUATION CLASS, C. 1910. Emma Garrett never saw a class graduate from the school. According to her sister, Mary, in a letter dated October 19, 1908, Emma "died in 1893 of nervous prostration caused by the hard struggle she had to establish the oral method in Pennsylvania against the opposition which she met." (SSSD.)

St. Cecilia's Academy. "Parents and guardians are respectfully informed that . . . St. Cecilia's Academy will open . . . for young ladies on the first Monday of September," 1878. Under their superior, Mother Mary Francis, the Sisters, Servants of the Immaculate Heart of Mary, expanded the typical curriculum for young ladies beyond music, drawing, and wax flowers to include geometry, astronomy, philosophy, chemistry, and languages, preparing their graduates for top colleges and universities.

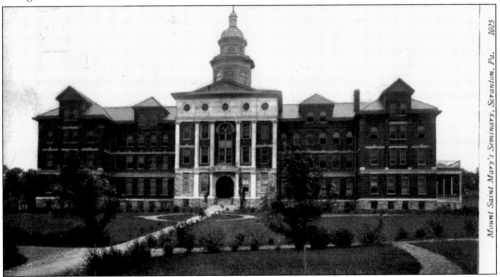

Mount Saint Mary's Seminary, Scranton, Pa. 1025

Mount St. Mary's Seminary. St. Cecilia's was a step toward a broader vision of education. Under Mother Cyril, superior in 1901, the sisters planned a new school. Mother Cyril chose the term *seminary* over *academy* to avoid the suggestion of a finishing school. Mount St. Mary's Seminary opened in September 1902 to be just what a young men's seminary would be: a place where the young scholars dedicated themselves to serious study. (BAH.)

MARYWOOD COLLEGE. The seminary was the next step toward an ultimate goal. The "far-seeing Mothers" wanted a rare thing: a college for women. Having limited opportunities themselves, the sisters sought first to advance their own educations. They "trained quietly and effectively within the convent walls where a well organized system of certification, carefully planned extension courses, and special summer courses" prepared them to teach at a college level. (MU.)

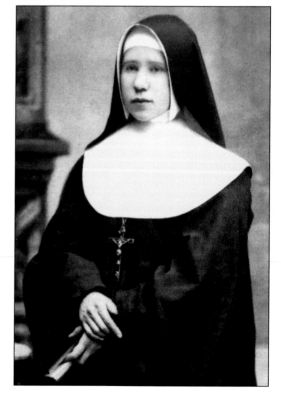

MOTHER M. GERMAINE O'NEIL. "[I]n a short time, the name of Marywood will be known far and wide." Mother M. Cyril Conway had set the groundwork for a college, and Mother M. Germaine O'Neil outlined the plan before state officials. They granted their support, on the condition that the sisters could attract enough students. Marywood College opened in September 1915 with 34 students and with Mother Germaine as president and treasurer. (MU.)

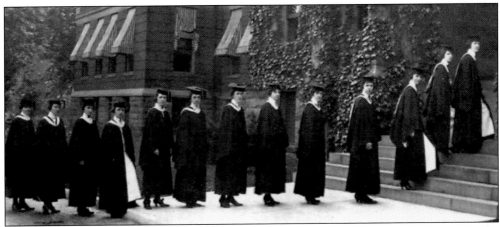

First Graduating Class, 1919. Arriving with enthusiasm, the "pioneer" class took up the challenge before it with determination. As quoted from the 1936 yearbook *Tourmaline*, with a commitment "to satisfy fully, by substantial and scholarly training, all aspiration to enlargement and elevation of mind," the school offered a curriculum that included history, philosophy, economics, art, music, and mathematics. The first class graduated with a bachelor of arts, a bachelor of science, or a bachelor of letters. (MU.)

Roger Bacon Chemical Society, 1923. The Roger Bacon Chemical Society "was organized in 1921 by the students of science for the purpose of stimulating interest in scientific achievements," stated Margaret Yarina's 1990 *Marywood College*. During the 1920s, science offerings included organic and inorganic chemistry, the Chemistry of Foods, qualitative analysis, physiology, and bacteriology. Marywood offered a bachelor of science degree in a premedical course, "a preparatory course arranged to meet the requirements of the Association of Medical Colleges." (MU.)

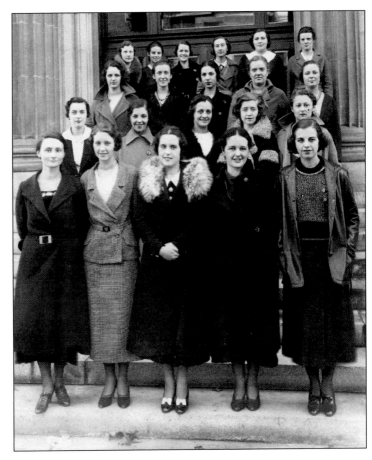

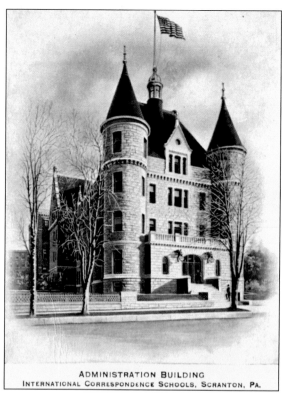

ADMINISTRATION BUILDING
INTERNATIONAL CORRESPONDENCE SCHOOLS, SCRANTON, PA.

INTERNATIONAL CORRESPONDENCE SCHOOL. The ICS was founded in 1891 by T. J. Foster to offer extension courses in mine safety for miners and mining engineers. By 1899, over 190,000 students had enrolled in ICS mining courses. Although originally founded to provide courses to men, the ICS added a woman's institute in 1916 that rapidly elevated all earlier enrollment tallies. (BAH.)

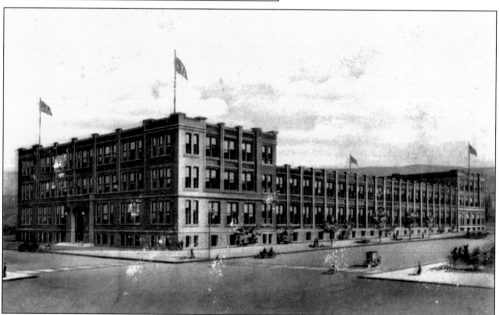

INSTRUCTIONAL DEPARTMENT AND PRINTERY, ICS. Grading of mailed assignments and tests took place in this building, as well as custom printing of textbooks specially designed to support correspondence education. Textbook author Mary Brooks Picken wrote 64 textbooks in the course of two years for her domestic science and arts curriculum for women (for example, *The One-Hour Dress and How to Make It*). (BAH.)

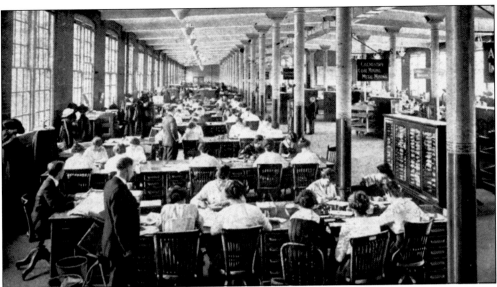

ICS OFFICE WORKERS. Daily, in what was purported to be the largest instruction room in the world, over 3,000 student lessons were checked by an employee pool that included many Scranton women, seated five abreast. Student work was next consigned to instructors and principals who checked it again. If deficient, student work was returned for reworking and resubmission. (JH.)

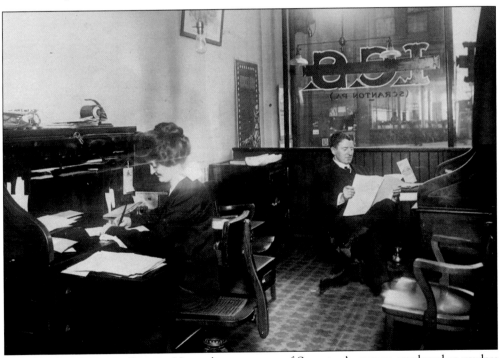

ICS ADMINISTRATIVE OFFICE. Not only were many of Scranton's women employed as graders and instructors, but an equally large number staffed the inner offices. Handwritten letters were soon replaced by typewritten ones, and telephones increased the speed of productivity. In a remarkably short period of time, the ICS became one of the most profitable educational ventures of the early 20th century. (JH.)

MARY BROOKS PICKEN, C. 1922. Mary Brooks Picken, born on August 6, 1888, in Kansas, had enjoyed sewing since childhood. Married to Harry O. Picken in 1906, she pursued a career in New York City that included editing a fashion magazine, directing the Fashion and Fabric School, and instructing in fashion economics at Columbia University. She was one of the original directors of the Fashion Institute, now at the Metropolitan Museum of Art. (PFS.)

THE WOMAN'S INSTITUTE, 1916. Picken arrived in Scranton on September 27, 1914, to write 64 textbooks for the curriculum she planned to direct. Her first student enrolled in the Woman's Institute of Domestic Arts and Sciences in 1916. By 1922, the school was the largest in the world devoted exclusively to the teaching of women. To accommodate the enterprise, construction of a new building began in 1921. (PFS.)

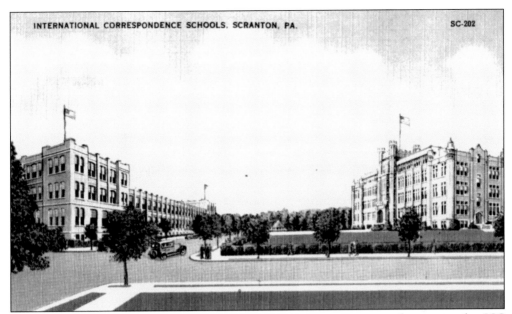

THE WOMAN'S INSTITUTE, 1922. The new institute was constructed opposite the ICS printery on Wyoming Avenue. The large Gothic Revival–style building, designed by William S. Lowndes (principal of the ICS School of Architecture) is still used for educational purposes today, although the woman's institute closed its doors in 1938. Acquired by the Jesuits in 1963, the building now houses Scranton Preparatory School. (BAH.)

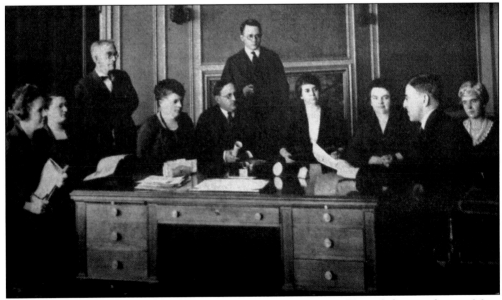

DEPARTMENT MANAGERS, THE WOMAN'S INSTITUTE, 1922. From left to right are Mary Brooks Picken, director of instruction; Jennie Davis; J. A. Hodges; Lillian Krauter; G. L. Weinss; R. K. Moore; Jane Thomas; Mary E. Coyle; G. Lynn Sumner, director of publicity; and Sara L. Bryne. Sumner, advertising executive, was the mastermind behind the successful marketing of the institute. (PFS.)

MARY BROOKS PICKEN AND MARY CARR, 1922.
Mary Brooks Picken (left), photographed on
the opening day of the institute, stands on the
steps of her new domain with actress Mary Carr.
Comparing the institute's first home to the new
building, Picken asserted that "such a remarkable
growth can be due to only one cause— . . . [that it]
is supplying a great human need." (PFS.)

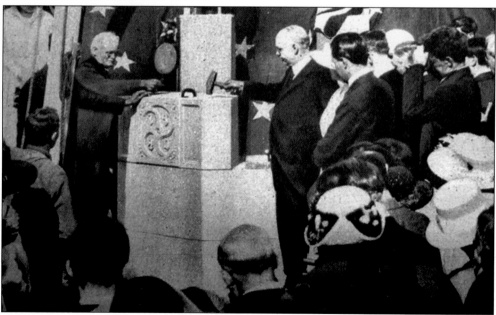

DEDICATION, WOMAN'S INSTITUTE, 1921. The ceremonial laying of the cornerstone of
the institute was attended by celebrities: Norma Talmudge (actress), artist Neysa McMein,
William C. Sproul (Pennsylvania's governor), and Dr. William Bawden (assistant United States
commissioner of education). The widowed Mary Brooks Picken and her future second husband,
G. Lynn Sumner, were of course present. (PFS.)

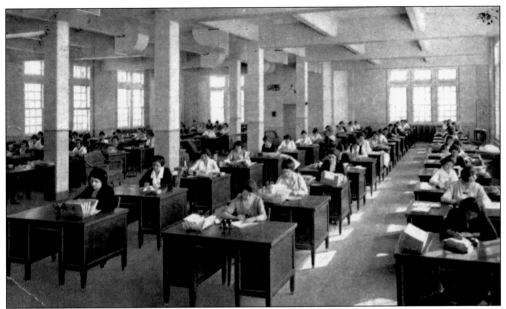

THE WOMAN'S INSTITUTE. The reverse of this postcard records, "The Woman's Institute of Domestic Arts and Sciences is teaching a knowledge of Dressmaking, Millinery, and Cookery in the most natural place in the world to learn—the home itself—through the use of textbooks that have been prepared especially for home-study." (JH.)

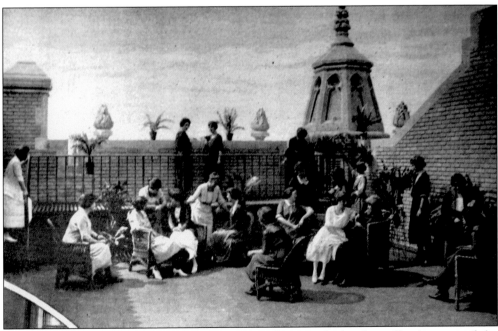

ROOF GARDEN, WOMAN'S INSTITUTE, C. 1922. An entirely female staff enjoys one of the amenities of employment at the institute, a moment of ease on one of the building's several roof gardens. The captioned photograph reads, "A happier, more intelligent and more enthusiastic group that those who carry on the Institute's work would be difficult to find." (PFS.)

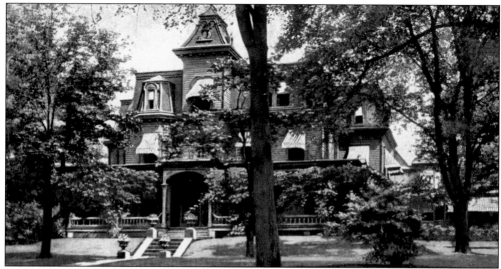

INSTITUTE HALL, WOMAN'S INSTITUTE, C. 1922. This was the center for out-of-town staff members employed by the institute. It was furnished as an attractive private residence and provided a "home away from home" for institute women, many of whom were single career women. (JH.)

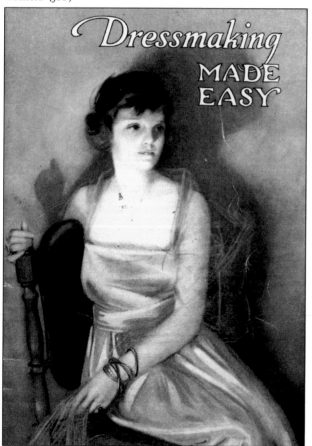

DRESSMAKING MADE EASY, 1920. Mary Brooks Picken, author, cautioned, "The plan of serving as an apprentice in a dressmaking shop is rapidly going out of use because dressmakers have not the time to teach beginners the rudiments of the work . . . Those who maintain shops prefer to hire at good wages skilled cutters, seamstresses, and fitters who can turn out work rapidly and well." (PFS.)

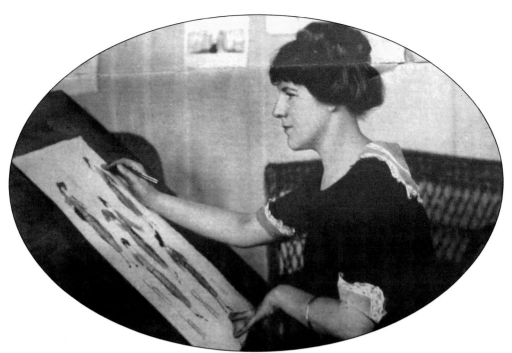

ALICE SEIPP, C. 1922. Alice Seipp maintained a studio at the institute. Widely regarded as one of America's leading fashion artists, she was employed exclusively by the institute to illustrate all the ICS-printed fashion textbooks. She also created drawings for the institute's two publications: *Inspiration* and *Fashion Service*. Both were mailed to students enrolled in fashion courses. (PFS.)

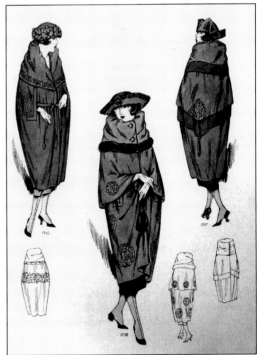

ALICE SEIPP, FASHION SERVICE, FALL–WINTER 1920–1921. The *Scranton Times* stated in 1914, "Fashion is ever whimsical . . . [The] woman . . . [who wears] the 'same' dress more than one season . . . [pays] the penalty of fashion. So long as [this is so and] . . . dressmakers are [seeing] to it that the styles will keep on changing, it is better that American dressmakers . . . be moulded to sensible American ideas." (PFS.)

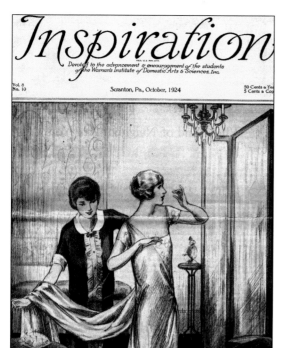

INSPIRATION, 1925. Costing 5¢ a copy and 50¢ per year, *Inspiration* was mailed to institute students. It was "Devoted to the Advancement and Encouragement of the students of The Woman's Institute of Domestic Arts and Sciences" and contained patterns, sewing instructions, and letters from Mary Brooks Pickens's deeply satisfied customers. She encouraged students to form community clubs and to enlist more students in domestic science. (PFS.)

SEWING MATERIALS. Students enrolled in courses regularly were mailed basic supplies necessary for at-home fashion design, home decorating, and cooking. Sewing students would receive items like those illustrated here: instruction papers, a tailor's square, a dressmaker's gauge, measure slips, a tape measure, a waist pattern, and drafting paper "fit for a seamstress." (PFS.)

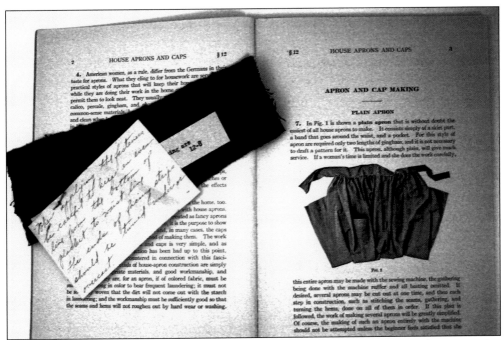

EXAMPLE OF STUDENT WORK. The Lackawanna Historical Society preserves the instruction manuals, exam questions and scores, and corrected student work of Alice H. Tolman. Corrections were written by institute staff and pinned to student exam samples, as seen here. Tolman is gently reminded to keep her seams straight and to overcast her facing strips.

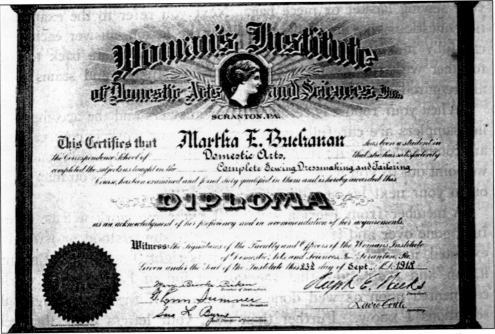

DIPLOMA, WOMAN'S INSTITUTE. As an inducement to industry and perseverance, a reproduction of the diploma was regularly printed in issues of *Inspiration*. It showed students what they would earn upon completing their courses and satisfactorily passing their final exams. (PFS.)

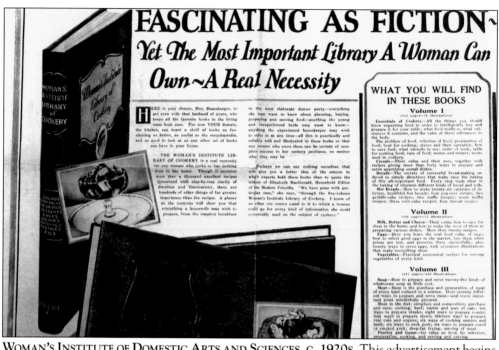

FASCINATING AS FICTION ~
Yet The Most Important Library A Woman Can Own ~ A Real Necessity

HERE is your chance, Mrs. Housekeeper, to get even with that husband of yours, who keeps all his favorite books in the living room book case. For now YOUR domain, the kitchen, can boast a shelf of books as fascinating as fiction, as useful as the encyclopedia, and as good to look at as any other set of books you have in your house.

THE WOMAN'S INSTITUTE LIBRARY OF COOKERY is a real necessity for any woman who cooks or has cooking done in her home. Though it contains more than a thousand excellent recipes (presented with step-by-step clarity of direction and illustration), there are hundreds of other things of far greater importance than the recipes. A glance at the contents will show you that everything a housewife may wish to prepare, from the simplest breakfast to the most elaborate dinner party—everything she may want to know about planning, buying, preparing and serving food—anything the young and inexperienced bride may want to know—anything the experienced housekeeper may wish to refer to at any time—all this is practically and reliably told and illustrated in these books so that any woman who owns them can be certain of complete success in her cookery problems, no matter what they may be.

Perhaps we can say nothing ourselves that will give you a better idea of the esteem in which experts hold these books than to quote the tribute of Elizabeth MacDonald, Household Editor of the Modern Priscilla. "We have gone with particular care," she says, "through the five-volume Woman's Institute Library of Cookery. I know of no other one source equal to it to which a woman could go for every kind of information she could conceivably need on the subject of cookery."

WHAT YOU WILL FIND IN THESE BOOKS

Volume I

Essentials of Cookery—All the things you should know regarding food in order to intelligently buy and prepare it for your table; what food really is, what substances it contains, and the value of these substances to the body.

The problem of food; selection of food; preparation of food; heat for cooking; stoves and their operation; how to save fuel; what utensils to use; order of work; table for cooking food; care of food; menus and recipes; terms used in cookery.

Cereals—Their value and their uses, together with recipes giving more than forty ways to prepare and serve appetizing cereal dishes.

Breads—The secrets of successful bread-making reduced to simple directions that make easy the baking of this all-important food. Every step made clear in the baking of nineteen different kinds of bread and rolls.

Hot Breads—How to make twenty-six varieties of delicious, healthful hot breads; four pop-over recipes, five griddle-cake recipes; two waffle recipes; seven muffin recipes; three corn-cake recipes; four biscuit recipes.

Volume II

Milk, Butter and Cheese—Their value, how to care for them in the home, and how to make the most of them in preparing various dishes. More than twenty recipes.

Eggs—Here you learn the real food value of eggs, how to select good eggs in the market, buy them when prices are low, and preserve them successfully; also, twenty ways to serve eggs, with seventeen illustrations that make everything clear.

Vegetables—Practical economical recipes for serving vegetables of every kind.

Volume III

Soup—How to prepare and serve twenty-five kinds of wholesome soup at little cost.

Meat—Here is the purchase and preparation of meat of every kind reduced to a science. Over seventy different ways to prepare and serve meat—and every important point wonderfully pictured.

Meat in the diet; structure and composition; purchase and care; cooking; beef; names and uses of cuts; ten ways to prepare steaks; eight ways to prepare roasts; four ways to prepare stews; thirteen ways to prepare veal cuts and organs; six ways of cooking mutton and lamb; six ways to cook pork; six ways to prepare cured or smoked pork; deep-fat frying; serving of meat.

Poultry and Game—Its value as food, its selection, preparation, cooking, and serving and carving.

WOMAN'S INSTITUTE OF DOMESTIC ARTS AND SCIENCES, C. 1920s. This advertisement begins with a variation on the proverbial battle of the sexes: "Here is your chance, Mrs. Housekeeper, to get even with that husband of yours, who keeps all his favorite books in the living room book cases . . . Your domain, the kitchen, can boast a shelf of books as fascinating as fiction, as useful as the encyclopedia." (PFS.)

ALICE NELMES, 1925. Among the testimonials included in the February 1925 issue of *Inspiration* was this from Alice Nelmes: "Since starting the courses, I have made my small daughters two bloomer dresses and embroidered the one she is wearing in the picture. You will notice the blanket stitching, so even the first lesson has been of much help to me." (PFS.)

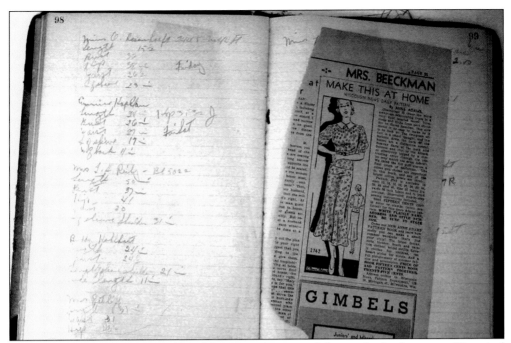

ACCOUNTS LEDGER. Among Alice H. Tolman's memorabilia at the Lackawanna Historical Society is this ledger, which reveals her flourishing career as a seamstress. Each page records the names and measurements of her clients. Pressed between the ledger's pages are newspaper clippings of patterns and dress designs popular in the 1940s.

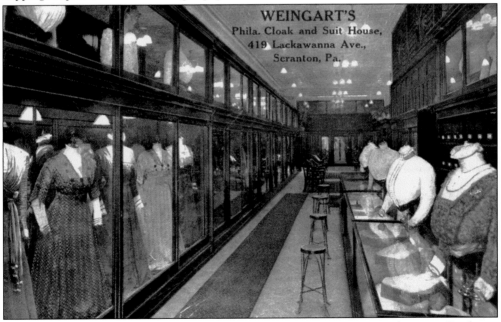

WEINGART'S PHILADELPHIA CLOAK AND SUIT HOUSE, 419 LACKAWANNA AVENUE. Graduates of the institute could begin careers as stay-at-home seamstresses or become employees and saleswomen in stores like Weingart's. As stay-at-home wage earners, they lived up to the ideal of "domestic feminism," which preferred to see women employed in, not outside, the home.

SCRANTON TRAINING SCHOOL, 1899. The Scranton Training School was established by school board resolution on August 24, 1891, and discontinued in 1910. Directed by its first principal, Laura J. Brice, it served as a normal school, or training school for teachers. Graduates were unmarried women, most of whom were accepted by the Scranton Board of Control as teachers. When a teacher married, she was required to resign her position.

TEACHERS, NO. 36 SCHOOL, 300 FRANKLIN AVENUE, 1892. The *Scranton Times* reported in 1914 that "when No. 36 [school] . . . opened in 1893, Miss Porcher [top, third woman from the left] was transferred . . . During Miss Porcher's 34 years as a teacher, there have passed exactly 6,800 school days and she has during each one been in the classroom teaching in all a total of 34,000 hours."

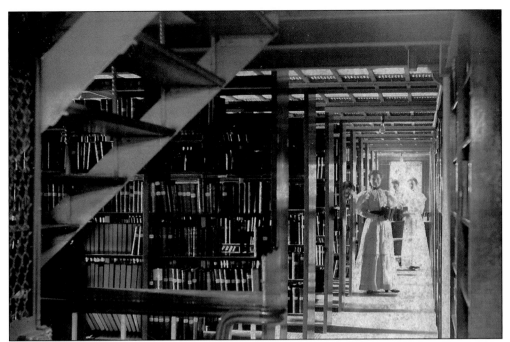

STACK ROOM, SCRANTON PUBLIC LIBRARY. After the Civil War, two careers for women burgeoned: nursing and librarianship. The number of employed librarians in the United States rose from 3,122 to 14,714 in the 50 years spanning from 1870 to 1920. When the Scranton Public Library was dedicated on May 25, 1893, its founders had amassed a collection of 14,600 books, all minutely cataloged in time for opening day.

EMMA THOMAS, c. 1892–1893. Emma Thomas was librarian at Dunmore's Green Ridge Library before the Scranton Public Library was built. Later she transferred to the Scranton library, where she worked alongside Edith Carr, another familiar figure at the reference desks and an authority on genealogy and local history. (Carr's husband was the first librarian of the Albright Memorial Library.)

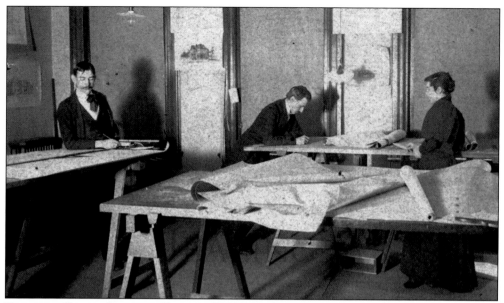

DRAFTING ROOM, OFFICE OF EDWARD H. DAVIS, ARCHITECT, CONNELL BUILDING, C. 1900.
Men and women studied architecture as apprentices of practicing architects around 1900, since architecture schools and their curricula were just beginning to form during the early 20th century. The young woman depicted here is possibly a student-apprentice, but it is equally as likely that she was a general office assistant.

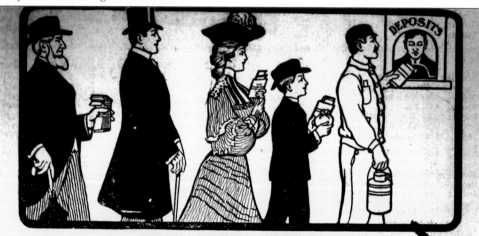

ALL CLASSES OF PEOPLE

who realize the importance of living happily and peacefully never feel contented until they have a **BANK BOOK** in their possession. It is the only and best safeguard in sickness and distress, and increases your credit at all places.

The simple manner in which a check is drawn affords great convenience besides the protection, as it acts as a receipt. We respectfully solicit your

ADVERTISEMENT, WEST SIDE BANK, 1930. This advertisement appeared in the *Scranton Times*, which reported "70% of men who die leave estates to women. Other facts just as interesting show that women work independently, invest independently, support themselves independently. 5% of stockholders in the AT&T are women. More than one-half the stockholders in the U.S. Steel Corporation and in the Pennsylvania Railroad are women. Let us laugh that off if we can." (TT.)

Five

THE HEALING ARTS

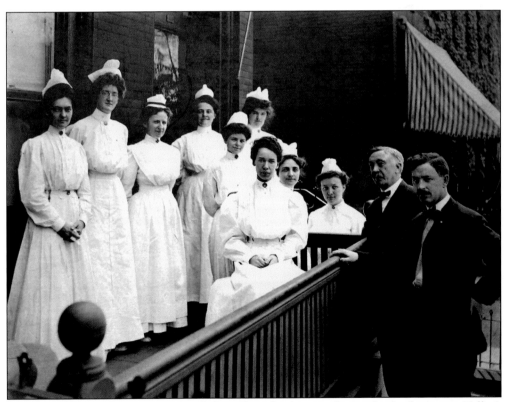

NURSES. These women were preceded in their healing profession by Lackawanna Valley's "Granny Sprague," who arrived in Scranton in 1771. Horace Hollister wrote that, for her midwifery, "no matter how distant the journey, how long or fatiguing the detention, this sturdy, faithful woman invariably charged one dollar for services rendered." Many of Scranton's early physicians were graduates of the Female Medical College of Pennsylvania (Philadelphia) that opened in 1850.

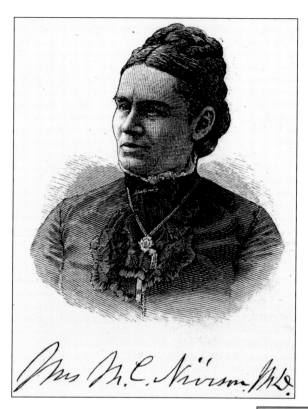

MRS. M. C. NIVISON, M.D. In 1883, Martha Rayne (*What a Woman Can Do*) surveyed the marital status of female physicians to discover that 75 percent were single. Not, however, Mrs. M. C. Nivison or her physican collegue Evelyn Nickey, who was one of three women in her dental class at Temple University School of Dentistry. After graduation 1919, she and her dentist husband opened their 36-year joint practice in downtown Scranton.

ANNA C. CLARKE, M.D. Anna Calista Clarke, born in Tioga County in 1869, first attended school in Athens and then became one of the first women to study at the University of Michigan when its medical school opened to women. She graduated with a medical degree in homeopathy in 1893 and came to Scranton five years later, after combating a typhoid fever epidemic in Allentown.

RESIDENCES ON JEFFERSON AVENUE. Dr. Clarke opened her general practice in the Jefferson Avenue home that also served as her office. She served on the board of Scranton's homeopathic hospital (Hahnemann Hospital) and was one of the original community founders of the Scranton chapter of the American Red Cross. By 1917, local membership had grown from 183 to 20,265, and the chapter comprised 34 branches and 74 auxiliaries.

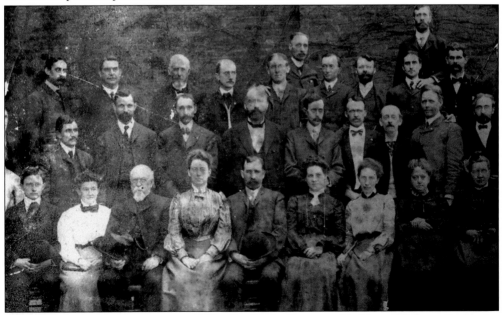

PHYSICIANS OUTSIDE DISPENSARY, 1890s. Dr. Clarke (first row, third from right) was diminutive in size but powerful in effect. She was president of the Lackawanna County League of Women Voters from 1926, when the league was founded, until her retirement in 1955. She was the first woman admitted to the Scranton Chamber of Commerce (1955) and was active in the legislative division of the local Business and Professional Women's Clubs.

YEARBOOK, THE COLLEGE CLUB, 1911–1912. A charter member of the College Club, Dr. Anna C. Clarke served, in 1921, on the board of directors of the Day Nursery Association founded by the club. She pleaded before Scranton's poor board for an annual contribution of $500 to support the charitable endeavor. The site of the first nursery was the former Dickson residence at 320 Washington Avenue (see page 111). (DML.)

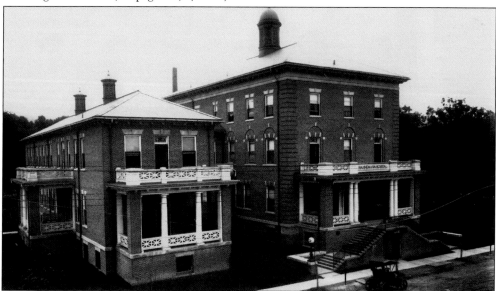

HAHNEMANN HOSPITAL, COLFAX AVENUE, 1905. Hahnemann Hospital (today Community Medical Center) was incorporated as a homeopathic medical center. It was managed by a board of philanthropic women in 1897, with Eleanor S. Oakford as its first president. Dedicated to realizing the beliefs of Dr. Samuel Hahnemann ("father of homeopathic medicine"), staff worked under the principle of benign medical treatment. The motto was "Above all, do no harm."

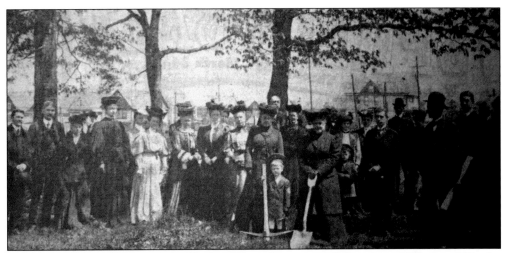

GROUNDBREAKING CEREMONY, HAHNEMANN HOSPITAL, MAY 24, 1905. In 1899, the Scranton home at 301 Monroe was the hospital's first site. In 1904, ground was broken at the new site, 300 Colfax Avenue, and a building erected to the design of Edward Langley. On this photograph, only the men are named even though the hospital board comprised entirely women until its bylaws were amended in 1920!

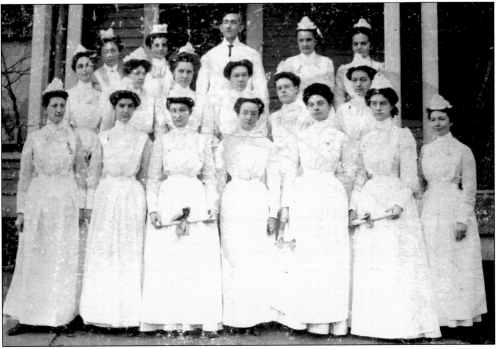

HAHNEMANN HOSPITAL GRADUATES, 1903–1905. The second superintendent of Hahnemann's Nursing Training School, Grace Smith (first row, fourth from left), was a graduate of Hahnemann Nursing School, Philadelphia. Aspiring nurses learned from the *Scranton Times* (1901) that "A good education is almost a necessity . . . but it is not an absolute necessity. You would have to apply to some hospital and with recommendations. Then you might be taken in and trained."

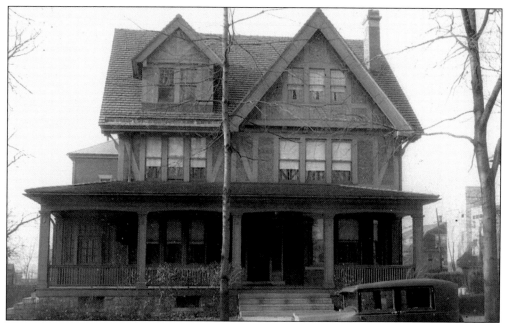

ROBINSON HOME, ARTHUR AVENUE. The former residence of entrepreneur Minna Robinson later became a residence for nurses employed by Hahnemann Hospital (now Community Medical Center). Sited near the hospital, the home provided convenience and security for unmarried career nurses.

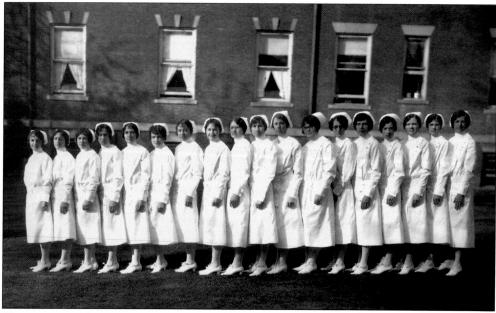

HAHNEMANN HOSPITAL GRADUATES, 1924. Superintendent Smith ensured that the goals of the training school were met in healing "the injured, sick and suffering of all classes," with preference for charity cases. The tradition continued into the Depression when 70 percent of Hahnemann patients were treated at no cost.

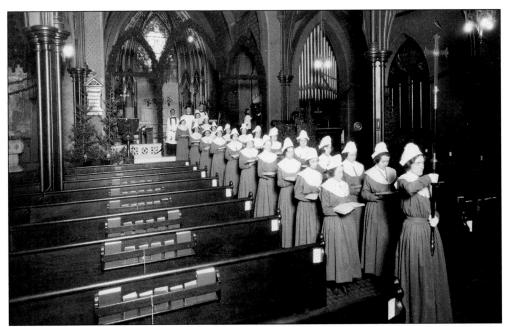

ANNUAL FLORENCE NIGHTINGALE SERVICE. Each year a service was conducted by Rev. D. Kreitler at St. Luke's Episcopal Church to honor the community's women nurses. In this photograph by John Horgan, the nurses process wearing the uniforms of Florence Nightingale's era.

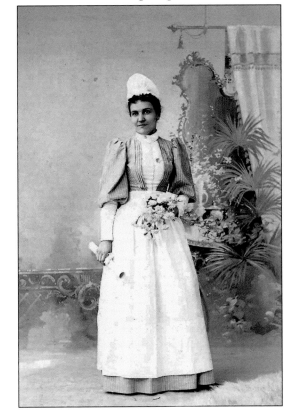

EDITH VANDERVOORT, 1895. Edith Vandervoort was a member of the first graduating class of the Lackawanna Training School for Nurses in 1895. In 1901, seven women from the school graduated in a ceremony held in St. Luke's parish house. During the ceremony, school president James P. Dickson paid tribute to "Mrs. W. T. Smith, who [had] constructed the children's ward as a memorial to her deceased husband."

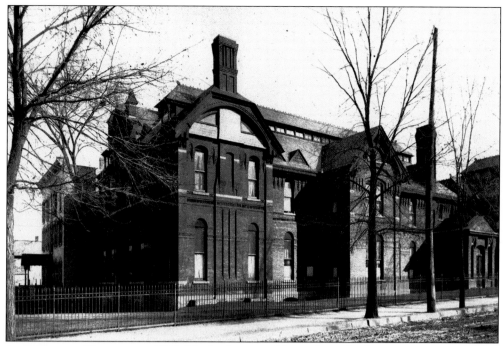

LACKAWANNA HOSPITAL, C. 1877. The Lackawanna Hospital was the first institution to establish a nurses' training school in this region. In 1914, Dr. Elias G. Roos, visiting staff surgeon, worked with 6 trained nurses and 43 student nurses. Frederick L. Hitchcock described the uniformed nurses as "a pretty sight . . . flitting to their duties between their home and the main building, or grouped on the beautiful lawn in summer." (RF.)

VISITING NURSES, 1915. Mrs. H. M. Boies was instrumental in founding, promoting, and, at times, single-handedly financing Scranton's first district nurses. Mary Kiesel, the first district nurse, earned a yearly salary of $150. At the time this photograph was taken, nurses received 50¢ per visit, a substantial increase from the 5¢ charged per visit in 1910.

VISITING NURSE, 1923.
Frederick L. Hitchcock
complimented Mrs.
Henry Boies, who
founded Scranton
District Nursing in 1909:
"Nothing in the field of
medicine and sanitation
in modern times appears
more striking than the
trend in medical and
philanthropic forces
towards the prevention
of disease and the
conservation of health."

VISITING NURSE, 1920S. The duties of a district nurse were varied and many. Besides relieving the sick through care and medication, she was expected to disinfect and sanitize homes, provide proper beds and food, and notify health authorities and parish churches of dire medical or social circumstances.

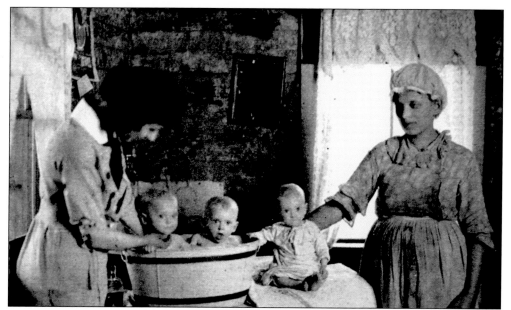

BATHING TRIPLETS, 1920S. The first baby welfare station managed by the district nurses was established in 1918 at 905 Robinson Street, while the second opened a year later on South Washington Avenue. Since 1910, district nurses had also held contracts with the Scranton School District to provide health care for students, and with Metropolitan Life for the care of its employees.

THE BICYCLE CLUB, 1888. The Scranton chapter of the American Red Cross, founded in 1916, was originally situated on the 300 block of Wyoming Avenue. Before arriving at its final and current site, it established headquarters in the former Dickson home at Washington Avenue; in Scranton's oldest clubhouse, the Bicycle Club (1925), and Scranton's Chamber of Commerce Building (1932).

SCRANTON CHAPTER, 545 JEFFERSON AVENUE. During World War I, the Scranton Red Cross collaborated with the women of the Century Club to make surgical dressings for the war. Both organizations also played a leading role in local post–world war relief efforts to assist battle-worn Belgium. In 1932, 545 Jefferson Avenue became headquarters for emergency preparedness and aid in Scranton and the surrounding region. (DHL.)

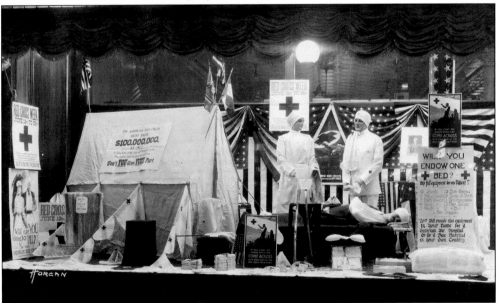

THE FINLEY WINDOW, SCRANTON. This storefront display celebrates Red Cross Week, June 18–25 and asks Scrantonians to endow one bed for $20. In 1917, the women of the Red Cross Motor Service provided transport to canteens, hospitals, and camps. In 1918, the chapter witnessed 6,644 Scrantonians treated for the Spanish influenza. (TT.)

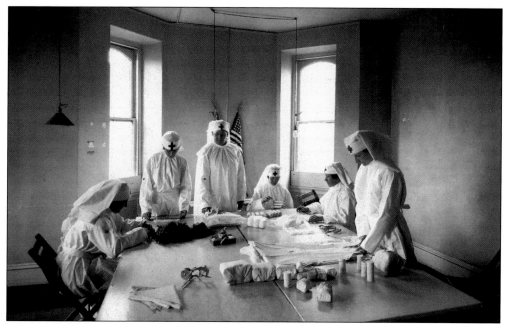

MAKING BANDAGES, RED CROSS, SCRANTON, C. 1916–1920. Bandage making, a central activity of Scranton's Red Cross during World War I, was followed by another catalyst to mobilization: the Great Depression of the 1930s. Through a Red Cross committee chaired by Mrs. E. B. Jermyn in 1932, the chapter distributed 2,225,000 pounds of flour to Lackawanna County's needy. (TT.)

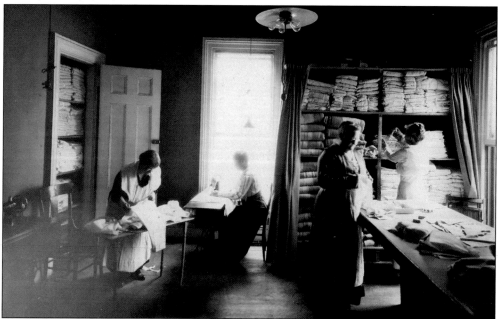

RED CROSS WORKERS. During the Depression and under the chairmanship of Century Club member Mrs. C. B. Little, the Red Cross solicited vacant lots as donations to create "Great Thrift Gardens"; vegetable seeds were supplied and county farm agent S. R. Zug was invited to instruct on food production. (TT.)

Six

THE SCRANTON CLUBWOMAN

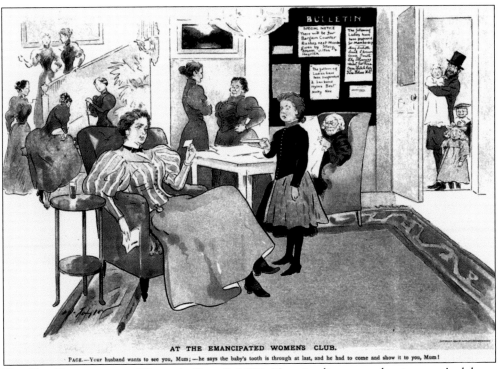

AT THE EMANCIPATED WOMEN'S CLUB.

PAGE.—Your husband wants to see you, Mum;—he says the baby's tooth is through at last, and he had to come and show it to you, Mum!

"AT THE EMANCIPATED WOMEN'S CLUB," 1896. Negative literature about women's clubs as destroyers of the American home proliferated in early-20th-century America. In this cartoon, the page girl standing before the relaxed, seated woman, says, "Your husband wants to see you, Mum;—he says the baby's tooth is through at last, and he had to come and show it to you, Mum." (LOC.)

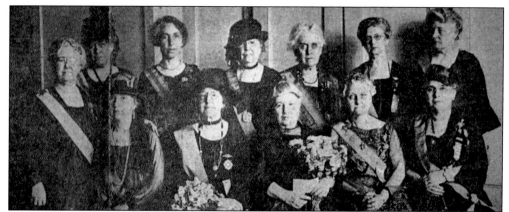

EDITH WELLBRIDGE CARR. Edith Carr (second row, second from right) founded the Scranton Colony of the National Society for New England Women. She was a charter member of Scranton's College Club (today the Scranton chapter of the American Association of University Women), the first local woman's club to join the State Federation of Pennsylvania Women (SFPW), in 1911. With cofounder Mrs. J. E. Sickler, she directed club sponsorship of college education for needy girls and established Scranton's first day nursery in 1910.

THE COLLEGE CLUB. Carr was treasurer of the College Club for 21 years and a member of the American Library Association (ALA). Born in 1856, she joined the ALA in 1882 and came to Scranton nine years later. She counted among her close friends Richard R. Bowker (*Library Journal* editor, 1876–1933), for whom she wrote a tribute when Pres. William McKinley appointed him librarian of the Library of Congress.

THE CENTURY CLUB, SCRANTON, 1917. The Century Club, with its threefold cultural, social, and civic mission, was founded in 1911, when Scranton's City Improvement Association merged with the Woman's Club (founded in 1909). Almost immediately, the club applied for membership in the SFPW and two years later was incorporated under the laws of the Commonwealth of Pennsylvania. Early meetings were held both in St. Luke's parish house and the YWCA. (CC.)

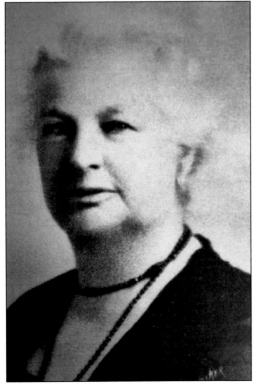

MRS. BENJAMIN DIMMICK. Mrs. Benjamin Dimmick was offered the first presidency of the Century Club but declined to continue her work as 1908 founder of the City Improvement Association. Through her efforts, attention focused on what women could do to improve the quality of life in Scranton: health, recreation, playgrounds, urban design, and parks. Eventually she became the Century Club's third president (1919–1921). (CC.)

91

LAKE PLACID, C. 1910. Mrs. Benjamin Dimmick (far left) and Ellen H. Warren (far right) served as Century Club delegates to the 1911 annual meeting of the State Federation of Woman's Clubs in Erie. They learned that "the establishment of a recognized headquarters gives a woman's club a community standing." Hence, the club began to look for a home. (WWS.)

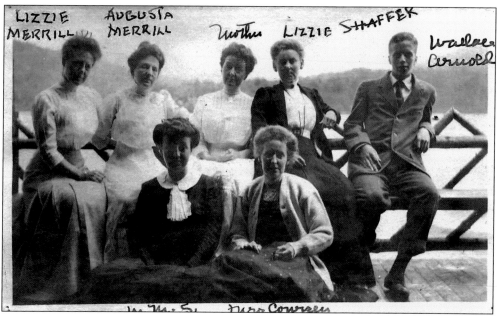

THE MERRILL SISTERS, LAKE PLACID, C. 1910. Pictured are, from left to right, (first row) Marion Margery Scranton and Mrs. Coursen; (second row) Lizzie and Augusta Merrill, Ellen H. Warren, Lizzie Shaffer, and Wallace Arnold. At their father's death in 1885, Elizabeth and Augusta continued to operate Merrill's Academic and Training School, founded in 1879. In April 1913, William W. Scranton purchased the school property and offered it to the Century Club for its clubhouse. (WWS.)

KATHERINE M. SCRANTON. Augusta Merrill's property was purchased for $10,000. By November 1913, club treasurer Katharine M. Scranton (née Smith) had raised an additional $25,000 from club membership and friends to finance construction of a clubhouse designed by Blackwood and Wilson, architects, at 612 Jefferson Avenue. Today the house is listed in the National Register of Historic Places. (CC.)

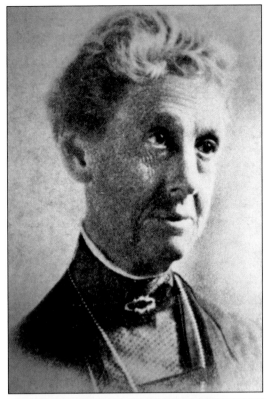

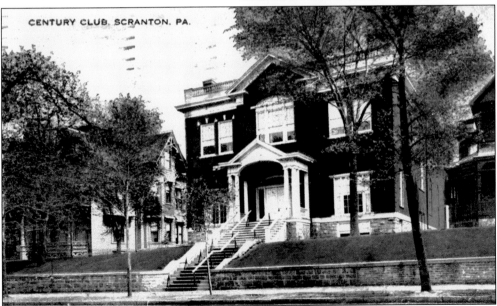

THE CENTURY CLUB. By charter, the Century Club existed for civic purposes. Civic activities included sponsorship of Cleanup Day, which became Cleanup Week, and ultimately the city's system of garbage collection, a survey of living conditions in Scranton through the Russell Sage Foundation for the city council, and a survey of charity in Scranton that led to the creation of Scranton's Community Chest. (JH.)

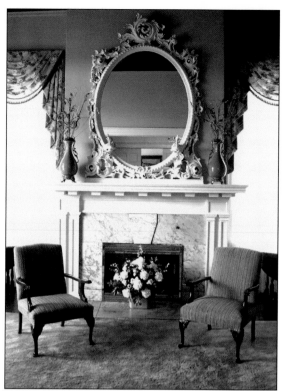

LOUNGE, THE CENTURY CLUB. During its first three years, the Century Club welcomed as speakers Rev. J. R. Atkinson, rector, St. Luke's ("Woman's Rights and Woman's Wrongs"); Anne E. George ("The Montessori Method"); Dr. Herbert E. Mills, economics department, Vassar College ("The Realization of the Socialist Idea"); Laura Platt ("Woman as Wage Earner"); and Alice Stebbins Wells, first woman police officer in the country (Los Angeles). (DML.)

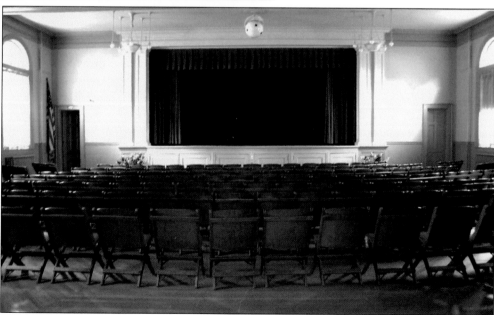

AUDITORIUM, THE CENTURY CLUB. The *Scranton Times* reported the club's production of a one-act play written by two junior members: *Cursed Event*. This 1933 satire on women's clubs presented the story of a women's club formed in hell, which the ladies had decided to reform and beautify. In the throne room of hell, Satan mourned, "Be warned of my lot, and learn of club women from me." (DML.)

WILLIAM WALKER SCRANTON'S CLOCK, THE CENTURY CLUB. Ellen H.
Warren related, "Mr. Scranton would come into the hall and gaze critically
about and then tell me the hall needed a great big clock . . . Finally
he . . . told me to go to Tiffany's and buy the best clock in New York and
send the bill to him. He died before the clock was placed." (DML.)

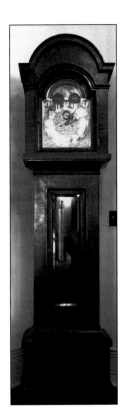

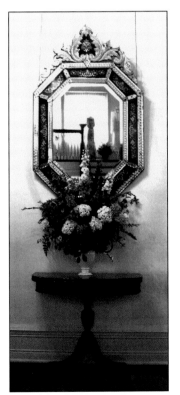

FRENCH MIRROR, THE CENTURY CLUB. William Walker
Scranton assisted the Furnishings Committee, chaired by
Mrs. L. A. Watres, in obtaining the best rug available for
the upstairs lounge and a blue French mirror that New York
decorator Mr. William Paris claimed once belonged to a
French castle. (Paris had been responsible for furnishing the
Scranton family home on Monroe Avenue.) (DML.)

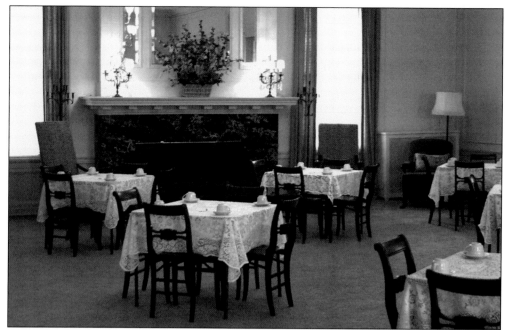

TEA ROOM, THE CENTURY CLUB. Although the ladies of the Century Club were uncertain as to whether they should present any stand on the issue of suffrage by allowing use of their rooms during the 1914 State Suffrage Convention in Scranton, they nevertheless opened their doors to the convention. They hosted a meeting of the Scranton Men's League for Suffragism as well. (DML.)

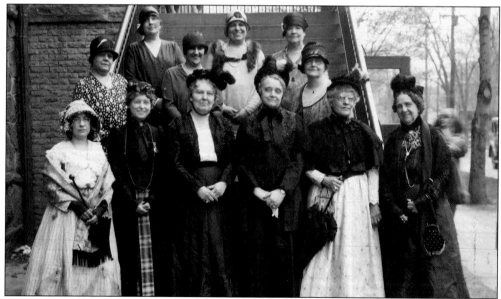

THE FORTNIGHTLY CLUB. Mrs. Matthew Shields stands in the first row, third from right. Many women's clubhouses served as meeting sites for other women's clubs, like Scranton's Fortnightly Club that organized for the purpose of literary edification. Few extant clubs continue to meet regularly in their original clubhouses. Scranton's Century Club does, which brings this 1911 progressive women's center into its current renaissance in the 21st century. (SF.)

NELLIE GLEASON. Nellie Gleason, first president of the Century Club (1911–1916), believed "there has been one other subject almost universal—that to which we properly refer as 'suffrage'—the question of the status of women as citizens. I have no hesitation in saying that among the clubs in the Federation, this subject has received a keener interest than . . . given to any other." (CC.)

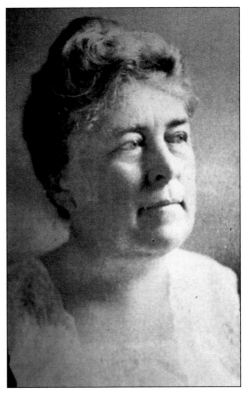

SARA LINEN AND CHILDREN. Sara Linen (née Scranton) was a charter member of the College Club and president of the Century Club during the 1930 SFPW Convention in Scranton. She is known locally as the motivating force behind creation of the farmers' market in the late 1940s (the market continues in operation today) and for her work with the Red Cross Nurse's Aides Corps during World War II.

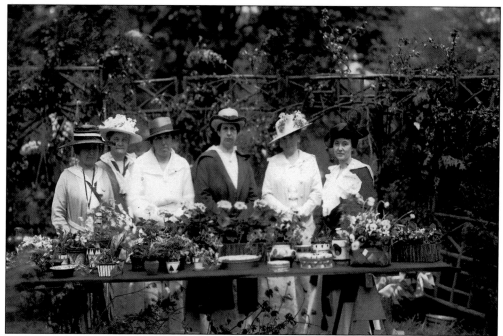

GARDEN PARTY. Sara Linen, third from the left, single-handedly operated Linair Farms in Waverly, and her love of flowers and plants was proverbial within the cadres of the Century Club. As chair of the club's social science department, she recommended a reading program designed by the philanthropic and social-minded Russell Sage Foundation. In 1937, she founded the Junior League of Scranton.

SARA LINEN. One of the controversial issues raised during Linen's Century Club presidency (1930–1932) was sterilization of the "feeble-minded," which was already legislated in 24 states. Mary Luckie, chairman of the SFPW Legislative Committee, was warning, "No state can afford to continue building institutions sufficiently large to take care of the problem of the feeble-minded." (CC.)

CONVENTION PROGRAM, SFPW 1930. Linen's opening remarks at the SFPW convention in Scranton were received by federation president Mrs. John A. Frick. One of the gala dinners was held in the "new" Masonic temple, and Friday luncheons took place in the homes of Linen and Mrs. G. d'Andelot Belin, Century Club hostesses for the conference. (BAH.)

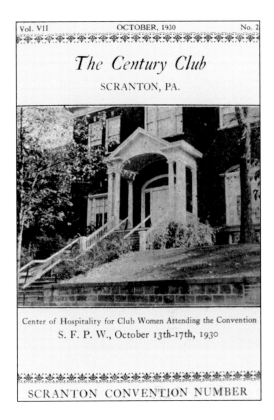

Vol. VII OCTOBER, 1930 No. 2

The Century Club

SCRANTON, PA.

Center of Hospitality for Club Women Attending the Convention

S. F. P. W., October 13th-17th, 1930

SCRANTON CONVENTION NUMBER

PROGRESSIVE Pennsylvania women will want to learn all the facts about voting machines and their advantages over the paper ballot. Besides permitting material savings in election costs, voting machines bring to elections an accuracy, efficiency and speed that is impossible to attain with the paper ballot.

How voting machines can serve your community, while paying for themselves out of savings, is told in an illustrative booklet which will be sent you.

Address Dept. M-12

AUTOMATIC VOTING MACHINE CORPORATION

JAMESTOWN NEW YORK

THE MESSENGER, SFPW CONVENTION PROGRAM, SCRANTON, 1930. In 1930, the SFPW was still encouraging women to vote. Seven years earlier, Scranton Republican women had admonished "the Indifferent Woman Voter": "It has been truthfully said that a majority of women have not yet awakened to their responsibility as voters . . . we have 32,000 women in the City of Scranton and only 5000 of these having voted." (BAH.)

(MRS. J. E.) CAROLYN P. SICKLER
VICE-PRESIDENT NORTHEASTERN DISTRICT

MRS. J. E. SICKLER. Century Club-woman Mrs. J. E. Sickler (bachelor of arts, Syracuse University, 1903) cofounded the College Club and organized its day nursery. She headed the Red Cross Department that secured books for soldiers overseas and organized the Lackawanna County Federation of Woman's Clubs and the Federated Parent-Teacher Association of Scranton. As district director of the northeast chapter of the SFPW, she traveled tirelessly throughout the region advancing women's causes. (BAH.)

HOTEL JERMYN. At the hotel, during the 1930 SFPW conference, Sickler heard Amelia Earhart, who pleaded "for women to become more air-minded," and Margaret Sanger, "who stirred the convention by her cool, sane arguments and her passionate devotion to the betterment of mankind." (JH.)

THE PENNSYLVANIA CLUBWOMAN. Sickler made moving pictures her personal crusade. She developed the federation's survey of motion pictures and encouraged clubwomen to pressure movie theaters into hosting Saturday matinees for children. In 1931, she became editor of the *Messenger* and changed its title to the *Pennsylvania Clubwoman*. (BAH.)

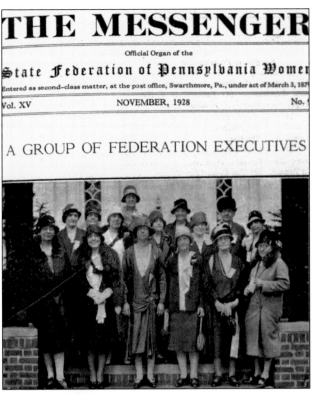

THE MESSENGER

Official Organ of the

State Federation of Pennsylvania Women

Entered as second-class matter, at the post office, Swarthmore, Pa., under act of March 3, 187

Vol. XV NOVEMBER, 1928 No.

A GROUP OF FEDERATION EXECUTIVES

ELM PARK CHURCH, SCRANTON CONVENTION, 1930. In the Elm Park Church house, Century Club members Mrs. James A. Linen Jr. and Sickler welcomed 805 ladies to the 35th annual conference of the SFPW. Session topics included White House conferences on child health and protection, correction and restoration in penal institutions, and what Pennsylvania was doing for its foreign-born mothers. (BAH.)

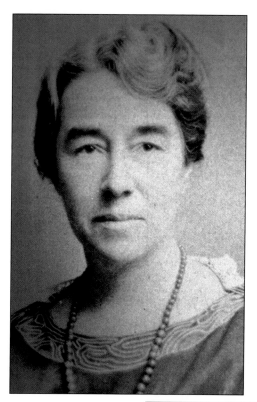

MRS. C. S. WESTON. Mrs. C. S. Weston was the Century Club president from 1916 to 1919. In 1910, as president of the Civic Improvement Association, she introduced a new design for the city by eminent urban designer John Nolen in an effort to transform Scranton into a "city beautiful." However, Scranton clubwomen saw Nolen's plan rejected by a city that chose tradition over the beauty of innovation. (CC.)

MAP OF SCRANTON AND THE LACKAWANNA VALLEY. Nolen believed that planning should begin with a city's topography, preserve its natural features, reflect its business needs, manifest its wealth, and project its traditions, ideals, and ambitions. His first analysis of Scranton entailed careful study of the topography in relation to the city's ongoing grid-plan development. (CC.)

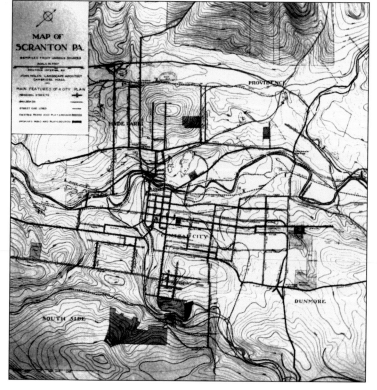

SOUTH SIDE, SHOWING RELATIONS OF STREETS TO CONTOURS. According to Nolen, "Street extension . . . is one of the main elements in the improvement of housing conditions, and it makes a vast deal of difference, both to present and future generations, whether the extension of streets is made on a purely commercial basis or whether due regard is paid to the common interests of the entire community." (CC.)

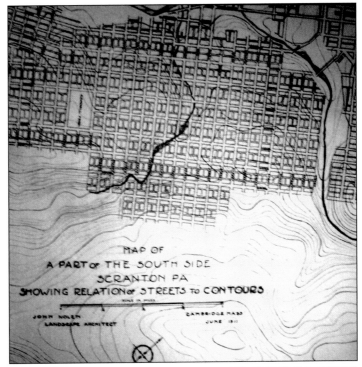

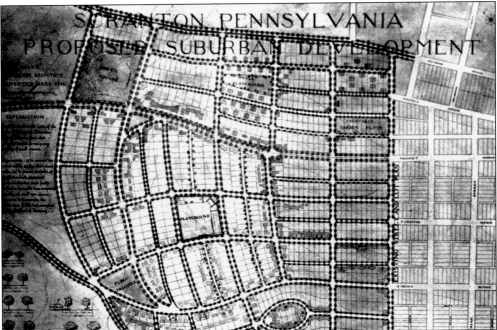

PROPOSED SUBURBAN DEVELOPMENT, SCRANTON. In this drawing, Nolen envisioned South Side development conforming to land contours. He advised, "In the preparation of this plan, I have kept constantly in mind two claims . . . the desire of land owners to secure the maximum return of the land . . . [and the importance] to the community at large of a standard that makes possible convenient and wholesome home conditions." (CC.)

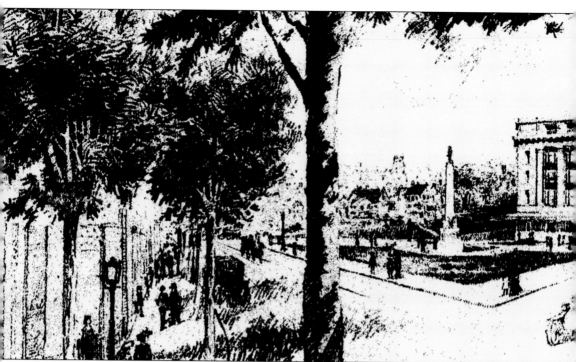

VIEW OF PROPOSED LACKAWANNA RAILROAD APPROACH. John Nolen's design for the juncture of Scranton's powerful railroad and thriving business districts promoted civic pride. In *New*

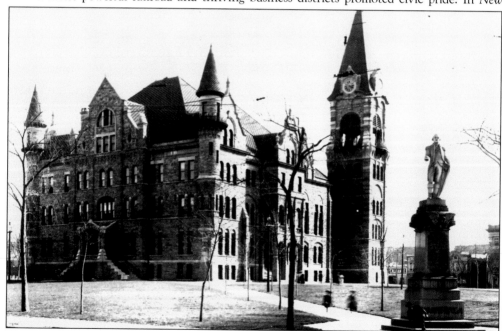

LACKAWANNA COUNTY COURTHOUSE. "Scranton is fortunate," Nolen observed, "in having a well-established focus, a central gathering place, like the fire or hearth of a household, a point in the city where interest and public life naturally concentrate. This focus is found in Court House Square . . . in which is located the Lackawanna County Court House." (CC.)

Ideals, he stated, "If action is taken soon enough, it is entirely practicable to re-plan the town so as to provide satisfactorily for its future." Imagine Nolen's vision of Scranton! (CC.)

NEW LACKAWANNA STATION, SHOWING APPROACHES, SCRANTON, PA.

DELEWARE, LACKAWANNA AND WESTERN RAILROAD STATION, 1908. "[This] . . . is one of the three or four noblest railroad approaches in the United States and the very least that . . . Scranton can do . . . is to provide an appropriate connection . . . to the center of the city." Nolen emphasized, "I know of no city where the problem of improving the railroad approach to the business section is so easy . . . [or] so advantageous." (CC.)

CHAMBER OF COMMERCE, LOUNGE. The Scranton Business and Professional Woman's Club met in the Scranton Chamber of Commerce building since it was originally a branch of the National Woman's Association of Commerce. Learning of the Pennsylvania Federation of Business and Professional Women (founded in 1919), the club sent May A. Emory to the first state convention (Pittsburgh, 1920). She was appointed federation director for one year.

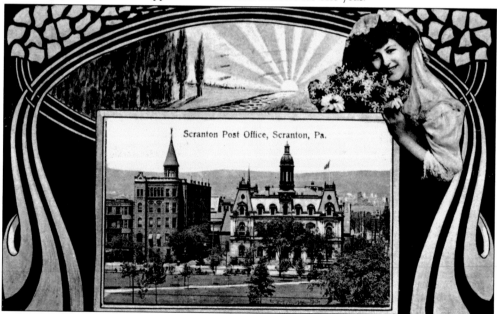

SCRANTON BUSINESS AND PROFESSIONAL WOMAN. An essay, "Old Maids," in the Business and Professional Women's April 1923 newsletter, the *Key*, asserted, "Simply because girls of today are hesitating a long time before they exchange their pay envelope for some man's dole doesn't call for slander or scorn. Rather it should call for admiration. They see the dangers of increasing divorce, unhappy homes, financial embarrassments, which are bad enough for one, let alone two." (BAH.)

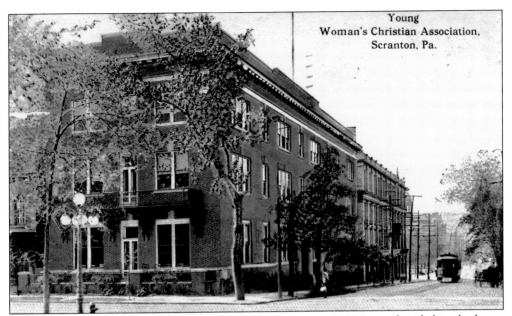

Young
Woman's Christian Association,
Scranton, Pa.

YWCA, JEFFERSON AVENUE, 1908. In 1888, the Scranton YWCA was founded in the home of its first president, Helen Dunn Gates, during a visit to Scranton of her sister, Nettie Dunn, YMCA national secretary. According to the *Scranton Republican* (1902), funds raised for the Scranton chapter were intended "to go toward established rooms where young women coming to the city as strangers may find home-like surroundings and innocent amusements."

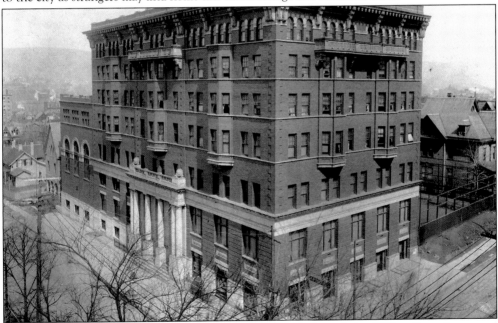

YMCA, SCRANTON, 1903. Design of the YWCA, dedicated in 1907, reflected external architectural features of the YMCA, dedicated in 1903. The exterior of both buildings is redbrick; each has a stone, columned portico as its principal entrance, and both were finished with a Renaissance-style cornice. The YMCA, however, was larger and more ornate in its design, reflecting the longer purse strings of its board members.

YWCA AND PLATT-WOOLWORTH BUILDING, C. 1930. In 1901, the *Scranton Times* had described the YWCA as a "great wall of security erected [around young girls] in their city life." It was the home of adventurous girls to whom "the home would be of incalculable value." But for all residents, it was envisioned as a "home permeated with Christian influences," and prayer and Bible-reading were regularly scheduled to meet the girls' spiritual needs.

YWCA SWIMMING POOL. In 1927, a need for increased space inspired F. J. Platt and C. S. Woolworth to donate money for a residence adjacent to the YWCA that contained rooms for 106 girls, an auditorium, and a swimming pool. According to the *Scranton Times*, the swimming pool was "second to none in the country, and the first pool for the exclusive use of women in Scranton."

AUDITORIUM, PLATT-WOOLWORTH BUILDING. In a letter soliciting financial support for the YWCA, Mrs. Ezra Ripple described what it had done for "young girls and young women in Scranton's factories, department stores, offices; by its various classes efficiently maintained; its gymnasium, its lunch room, where the best minimum cost to the workers [was available to those] who must economize, perforce to the last possible cent."

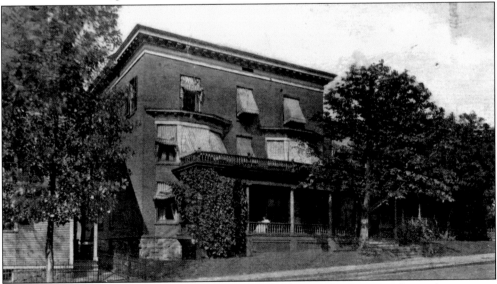

KATHERINE SIMPSON BOARDING HOUSE. In 1906, Clarence D. Simpson donated a property to the YWCA for a boardinghouse honoring his wife, Katherine. According to Mrs. Ripple, boarders who worked in the silk mills "were recognized as the best workers and were always looked upon with respect. One of the things a number of the girls did was form prayer groups and meet . . . during their lunch period." (JH.)

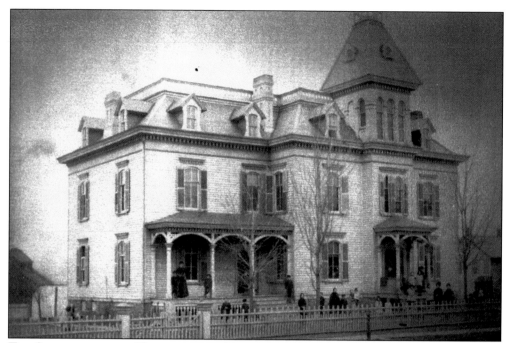

THE SOCIETY FOR THE HOME FOR THE FRIENDLESS WOMEN AND CHILDREN OF THE CITY OF SCRANTON. The home was incorporated by 10 ladies in 1873 and managed by 24. Of its residents in 1874, recording secretary Mrs. H. F. Warren stated, "Their relief and care is especially women's work. Let us take heed that we pass none by, whose sorrows, faults, or misfortunes will be requited at our hands."

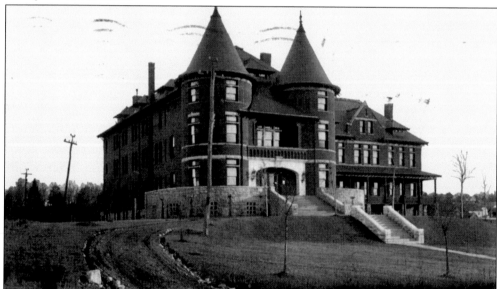

HOME FOR THE FRIENDLESS. In 1901, the *Scranton Times* enjoined Scrantonians, "there is no room for distinction of creed, party, race, or sex; it is as broad as humanity . . . and the splendid work accomplished by the noble women . . . should and will have the heart aid and support of the public." By 1888, 732 women and children had already passed through the home's great doors. (BAH.)

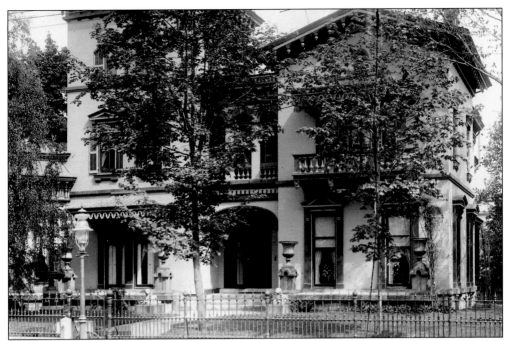

JEWISH HOME FOR THE FRIENDLESS. In 1915, Selma Stark, during a meeting of the South Side Ladies Aid Society, proposed founding the Jewish Home for the Friendless to assist the poor, orphaned, and elderly among Scranton's Jewish population. The founding women paid 15¢ each month and by 1921 had raised $10,294.47 through solicitation and subscription. With these funds, they purchased the former Weston estate. (JHEP.)

SELMA STARK. Recognizing the considerable amount of training and experience an orphanage entailed, Stella Stark (president 1916–1938) invited several men to the Jewish Home for the Friendless and persuaded them to assume duties of management and operation as a board of directors. When Dr. Aaron S. Cantor became chairman of the board in 1922, four adults and seven children resided in the home. (JHEP.)

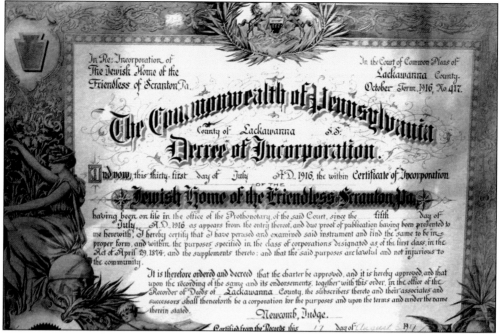

INCORPORATION CERTIFICATE, JULY 21, 1916. The women who signed their names to the charter of incorporation establishing the Jewish Home for the Friendless of Scranton did so to assist and provide "a home for the Orphans and the Aged of both sexes." Signatories were Selma Stark (president), Bertha Phillips (vice president), Emma Kilberg (second vice president), Yetta Dorfman (treasurer), Bertha Judovics (assistant treasurer), and Julia Legman (recording secretary). (JHEP.)

BLANCHE HULL, SUMMER 1914. The Girl Scouts, Scranton Pocono Council, founded June 6, 1917, became the 38th council chartered by the national organization in 1918. The first local troop, the Sunflower Troop, comprised 24 girls under the leadership of Blanche Hull, who served as council president from 1918 to 1922. In 1928, Lou Hoover (wife of Herbert Hoover) came to Scranton to attend the regional Girl Scouts council held here. (GSSPC.)

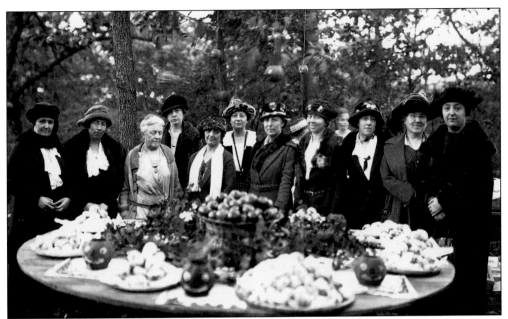

THE GIRL SCOUTS, SCRANTON PCOCNO COUNCIL, C. 1923. This photograph, taken at the first outing at Pen-y-Bryn, is pasted into in a 1920s scrapbook at the Scranton Pocono Council headquarters. Written below the image are names for some of the women: Mrs. Mark Edgar, Grace Hicks, Mrs. Watres, Ruth Scheuer Powell, Mrs. R. W. Archbald, Mrs. Mortimer G. Fuller, and Mrs. Keller. (GSSPC.)

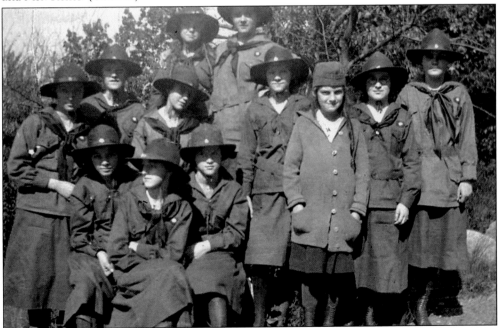

THE SUNFLOWER TROOP, SCRANTON GIRL SCOUTS, 1918. This rare photograph depicts the first local troop of Girl Scouts. In 1918, when the Scouts began camping, they pitched tents near Scott's Cottage near Elmhurst and at the first established Girl Scouts camp at Lake Coxton, administered by local director of the Scranton Council, Mabel Christ. (GSSPC.)

FLORENCE YOST AND MARY MANLEY, 1923.
Fun-loving Florence Yost was the second
council executive director (1922–1927), ably
following in the footsteps of Mabel Christ.
Camp Ely (as Camp Archbald was first
named) was into its second year of operation
as a working camp when this photograph was
taken. In 1923, a trading post was added to
the camp to provide gimp, snacks, postcards,
and camp apparel. (GSSPC.)

CAMP ARCHBALD POSTCARD, C. 1921. In 1920, Camp Archbald, the second-oldest continuously
operating Girl Scouts camp in the United States, was purchased by the Pcocno Council Camp
Committee chaired by Mrs. Thomas F. Archbald. The first camping season occurred in 1921,
when 76 girls enrolled for eight weeks at a cost of $7 a week. (GSSPC.)

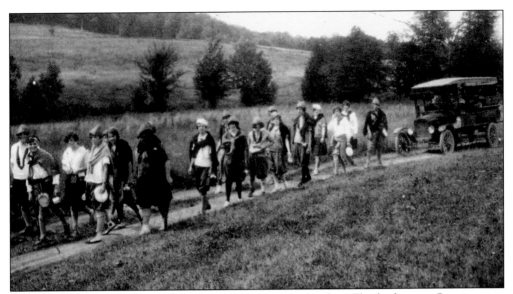

HIKE TO VIRGINIA, EARLY 1920s. Mrs. Sickler, whose daughter Elizabeth was a Scout, wrote, "[The Girl Scout] . . . is about the best phase of the growth in womanhood since Susan B. Anthony announced that women were people. From now on they are going to be finer and a more competent people, for they have found their legs, and their arms, and the freedom of outdoors in which to swing them. (GSSPC.)

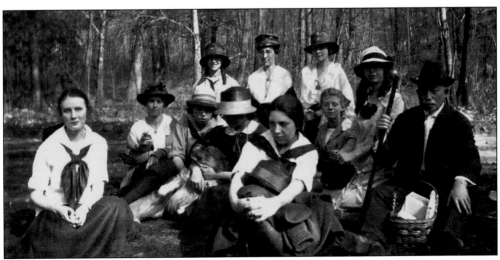

CAMPING IN VIRGINIA, 1920s. "There was a time, not so long ago, but that it is dear to memory, when a girl . . . had to hide her fitness to live and do her work in the world if she were to be happy about it. Those were the stupid days. The Girl Scout is the symbol of the coming generation, free, strong, competent and clean," asserted Mrs. J. E. Sickler in 1928. (GSSPC.)

CAMPFIRE SONGFEST, CAMP ARCHBALD, EARLY 1920S. According to the 1920 Girl Scout handbook, "The arts of fire building are not so simple as they look. To practice them successfully in all sorts of wild regions, we must know the different species of trees one from another, and their relative fuel values, which as we shall see, vary a great deal." These Scouts clearly know their woods. (GSSPC.)

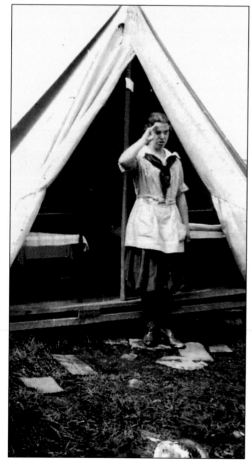

GIRL SCOUT, 1920. In the foreword to the 1920 Girl Scout handbook, R. Baden-Powell writes, "If the women of the different nations are . . . members of the same society and therefore in close touch and sympathy . . . although belonging to different countries, they will make a real bond not merely between the Governments, but between the Peoples themselves and they will see to it that it means Peace and that we have no more of war." (GSSPC.)

Seven

LADIES OF LEISURE

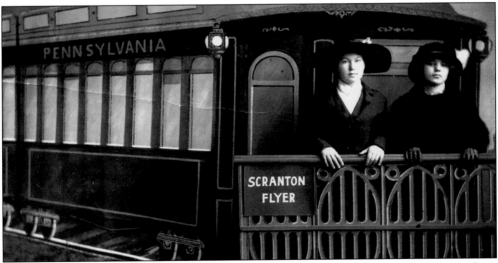

ABOARD THE TRAIN, 1906. This cosmopolitan-seeming duo is posed in front of a photographer's studio backdrop that suggests the independent and adventuresome spirit of these young women. Gov. William W. Scranton provides a context for the image, relating that his mother, aged 16, was allowed by her father to take a train alone to Harrisburg for suffrage work. "And that, in 1900, was just unheard of!" (JH.)

LUNA PARK, 1906. In 1905, the Scranton Board of Trade cited among the city's needs a state fair and free public baths. Moral opinion did not always concur since the prevailing idea among early-20th-century sociologists was that female sexual delinquency took root in leisure activities that lured young women from the security of their home to amusement parks, dance halls, and the like. (JH.)

ALONG THE ROAD, FROM EAGLE ROCK TO CRYSTAL LAKE. Weekends during the early 20th century were family occasions, and Sunday dinners were often followed by an automobile ride, for those with cars, or walks around lakesides and through glens with friends. Scranton's trolleys became an outstanding feature of the weekend recreation scene. (JH.)

MOOSIC LAKE GLEN, POSTMARKED 1908. Climbing the cascades in Moosic Lake Glen provided exercise that early-20th-century women physicians encouraged of their female clientele. One of the primary concerns of early-20th-century social movements was reform of the evils associated with urban centers devoid of playgrounds and public parks. (JH.)

Dancing Pavilion, Rocky Glen, Scranton, Pa.

DANCE HALL AT ROCKY GLEN. In October 1910, the Wilkes-Barre *Times Leader* reported, "Women Want Many Laws to be Revised." The usual legislative concerns were expressed (child labor, juvenile courts, working hours of women), but two other issues were on the reform agenda: the condemnation of public dance halls and censorship of movie shows. Public entertainment locales spelled moral danger, and, consequently, young single women often moved about in pairs or groups. (BAH.)

BOATING AT ROCKY GLEN, C. 1900. A winter advertisement in the *Scranton Times* in 1901 retails the pleasures of afternoon and evening ice-skating at Rocky Glen. More importantly, it assures readers of the "patrolling of the lake by guards who prevent rowdyism of all sorts and protect women and children, making their stay at the Glen one of good, healthy exercise and recreation." (JH.)

UNKNOWN CALL GIRL. Other "Ladies of Leisure" walked city streets. In 1901, the *Scranton Republican* reported, "Maggie Smith was fined $25 or 30 days by Alderman Millar for keeping a bawdy house. She came to this city but 3 months ago and has already gained a considerable notoriety. She took up residence at 313 Raymond Court. The place was raided Saturday morning. She was committed to the county jail."

Eight

VARIOUS AND SUNDRY

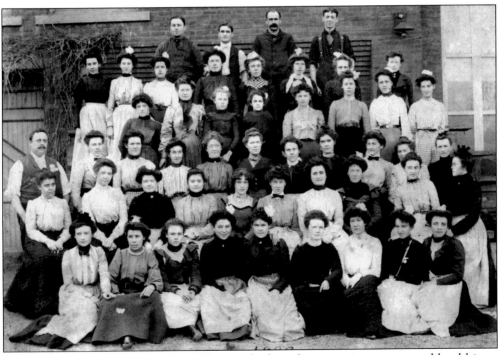

NEEDLE TRADES, 1899. The silk and lace trades brought prosperity to some and hardship to many employees. White lung was a common ailment and missing digits another. Labor reformer Mother Jones met "some with their hands off, some with the thumb missing, some with their little fingers off at the knuckle." One young woman was scalped at the Saquoit Silk Mill in 1910 when her hair was caught in the machinery.

Be Earnest Be Thorough
Be Kind

MISS SUPERINTENDENT OF SCHOOLS. The adjacent motto sets an expectation of conduct for Scranton public schools. Evelyn Brooks, superintendent of Scranton schools from 1879 until 1884, however, reported poor buildings, lack of blackboards and textbooks, and "vile . . . toilet conditions." Although "a conscientious and faithful official," historian Thomas Murphy notes, she "sometimes defeated her own purpose by criticizing men too sharply." She was not reelected to her post.

CATHERINE DELACY ROCHE. Women of the 19th century exercised political power wherever they could. After the Civil War, the GAR held annual meetings called encampments. The veterans' wives and daughters formed groups called "tents," and the women's auxiliaries shared the GAR's political power. Catherine DeLacy Roche, daughter of Medal of Honor winner Patrick DeLacy, founded the first tent and was elected national president of the Ladies of the GAR. (GR.)

"I WILL SING UNTO THE LORD." On December 14, 1905, Bishop Michael J. Hoban barred female voices from Catholic choirs throughout the Diocese of Scranton. This photograph is a view of the nave and altar of Scranton's cathedral, consecrated St. Peter's in 1884.

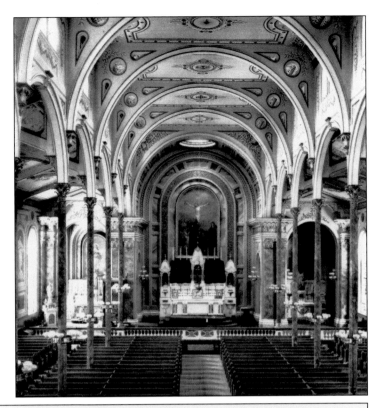

Scranton-Lackawanna Business College

"The School of Successful Graduates"

ADVERTISEMENT, SCRANTON BUSINESS SCHOOL. One historian noted that the Progressive Era found "women successfully conducting large business enterprises and at the head of important concerns." Yet women of the era, like Mrs. H. D. Buck, who took ownership of the Scranton Business School upon the death of her husband in 1911, often headed businesses because they succeeded their husbands. Buck quickly sold her enterprise. Other women retained their businesses and flourished.

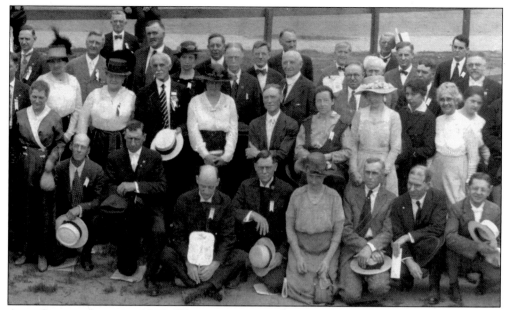

ANTI-SALOON LEAGUE, 1919. "Temperance is moderation in the things that are good and total abstinence from the things that are foul," said Frances Willard. From 1893 to 1933, the Anti-Saloon League was a major force in American politics. Temperance and women's suffrage were closely connected movements, and during the 1914 Woman's Suffrage Convention, the *Scranton Times* reported that it was rumored that local purveyors of alcohol opposed the vote for women.

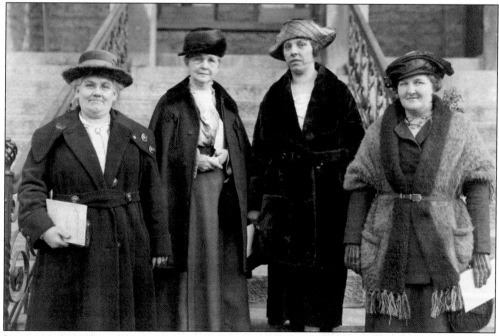

LADIES OF THE JURY. The hard-won right to vote brought with it a broader foray into civic life. Pictured in this 1921 photograph are the first women to serve on a jury in Lackawanna County. From left to right, they are Ruth Lewis, Anna Evans, Hannah B. Wilson, and Josephine Loftus. (TT.)

Sr. Immaculata Gillespie, I.H.M. In 1921, Sr. Immaculata Gillespie, dean of Marywood College, became the first area woman to earn a doctoral degree. Throughout the 1920s, the mission of "acquiring and sharing . . . spiritual and secular knowledge" was reinforced. With few colleges open to women, the sisters made special arrangements to earn advanced degrees from the University of Chicago, the University of Pennsylvania, Fordham University, the University of Notre Dame, Villanova University, and New York University. (MU.)

GIRL SCOUTS, CAMP ELY, 1923. The generation of girls who came of age in the 1920s had a much different sense of possibility than their foremothers. Women enjoyed new educational and professional opportunities. The right to vote was theirs from birth. The new era brought clothing reform and a new "disposition." For the Girl Scouts bobbing their hair in 1923, it was a brave new world. (GSSPC.)

PHOTOGRAPH CREDITS

The following are the complete photograph credits for the images found in this book. The images are identified by their placement on each page as top photograph (t) and bottom photograph (b).

AMO (Courtesy Ann Marie O'Hara), 35b

BAH (Courtesy the Pennsylvania Historical and Museum Commission, Bureau of Archives and History), MG 73: 36b; MG 213: 14t, 22t, 37t, 55t, 59b, 62t, 62b,65t,106b,110b, 119b; MG 386: 99t,99b,100t,101,101b

CC (Courtesy the Century Club), 34t, 91t, 91b, 93t, 93b, 97t, 98b, 102t–104t,105t

CU (Courtesy the Kheel Center for Labor-Management Documentation and Archives, Cornell University, Copyright Felker, Easton, PA), 43b

DML (Courtesy Darlene Miller-Lanning), 19, 80t, 87t, 94t, 94b, 95t, 95b, 96t

FMC (Courtesy Frank M. Clemens), 33b, 36b

GR (Courtesy Gary Roche), 122b

GSSPC (Courtesy Girl Scouts, Scranton Pocono Council), 112b–116b

JH (Courtesy Jack Hiddlestone), 2, 15t, 24t, 33b, 36t, 63t, 63b, 67t, 93b, 100b, 109b, 117t–120b

JHEP (Courtesy the Jewish Home of Eastern Pennsylvania), 111b–112t

LOC (Courtesy Library of Congress Prints and Photographs Division, Washington, DC), 37b (AP101.P7 1915), 89 (AP101.P7 1896), 30b (SSF-Music-Bands)

MU (Courtesy Marywood University), 59t, 60t, 60 b, 61t, 61b

PAHM (Courtesy the Pennsylvania Historical and Museum Commission, Bureau of Historic Sites and Museums, Pennsylvania Anthracite Heritage Complex, Gift of Hilary F. Krueger-Jebitsch), 23 (AC 2002.12)

PAHM (Courtesy the Pennsylvania Historical and Museum Commission, Bureau of Historical Sites and Museums, Pennsylvania

Anthracite Heritage Museum, E. Milton Fairchild's manuscript of the 1902 Anthracite Coal Strike), 22b (AC 2002.12)

PAHM (Courtesy the Pennsylvania Historical and Museum Commission, Bureau of Historical Sites and Museums, E. Milton Fairchild's manuscript of 1902 Anthracite Coal Strike, Gift of Mr. and Mrs. Walter G. Kramer. Formerly Carl A. Luft Collection), 24t (AC 82.29)

PFS (Courtesy the Penn Foster Schools, Scranton, PA), 64t, 64b, 65b, 66t, 66b, 67b, 68b, 69t, 69b, 70t, 70b, 71b,72t, 72b

RF (Courtesy the Robinson family, Mary Beth Jaditz and Robbie Hoffmann), 82t

SF (Courtesy the Shields family), 96b

SSSD (Courtesy Scranton State School for the Deaf, Archives and Museum), 54b, 55b, 56t, 56b, 57t, 57b, 58t, 58b

TT (Courtesy the Times-Tribune), 35t, 43t, 76b, 87b, 88t, 88b

UAF (Courtesy Thoeseeu Collection, #93-151-445. Archives, Alaska and Polar Regions Collections, Rasmuson Library, University of Alaska, Fairbanks), 16t

VMFAR (Courtesy the Virginia Museum of Fine Arts, Richmond, Alice Cordelia Morse, American, [1862-1961]. Kate Carnegie, c. 1896 [90.114], the Arthur and Margaret Glasgow Fund and the Sydney and Frances Lewis Endowment Fund, photograph by Linda Loughran, copyright Virginia Museum of Fine Arts, Richmond), 26

WOC (Reproduced in Frances E. Willard and Mary A. Livermore, A Woman of the Century [Buffalo: C. W. Moulton, 1893], 523), 25b

WWS (Courtesy Governor and Mrs. William W. Scranton), 38t, 38b, 39t, 39b, 40, 41t, 92t, 92b

DISCOVER THOUSANDS OF LOCAL HISTORY BOOKS
FEATURING MILLIONS OF VINTAGE IMAGES

Arcadia Publishing, the leading local history publisher in the United States, is committed to making history accessible and meaningful through publishing books that celebrate and preserve the heritage of America's people and places.

Find more books like this at
www.arcadiapublishing.com

Search for your hometown history, your old stomping grounds, and even your favorite sports team.

Consistent with our mission to preserve history on a local level, this book was printed in South Carolina on American-made paper and manufactured entirely in the United States. Products carrying the accredited Forest Stewardship Council (FSC) label are printed on 100 percent FSC-certified paper.

MADE IN THE USA